Withdrawn

IMAGES
of America

GROSSE ILE

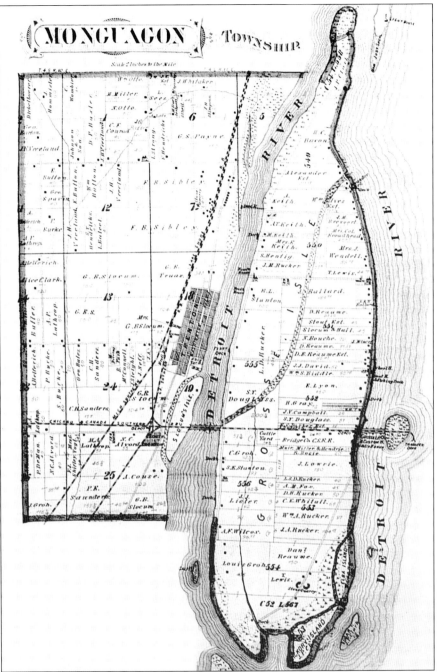

This 1876 map appeared in the *Illustrated Atlas of the County of Wayne, Michigan* by H. Belden and Company, Chicago.

On the cover: In about 1915, a group of boys and their dog are shown enjoying the water off Slocum's Island, the site of the present DTE Energy power plant. The railroad bridge crossing the Trenton Channel to Grosse Ile is behind them with Grosse Ile at the right. (Courtesy Grosse Ile Historical Society.)

IMAGES

of America

GROSSE ILE

Grosse Ile Historical Society

ARCADIA
PUBLISHING

Published by Arcadia Publishing
Charleston SC, Chicago IL, Portsmouth NH, San Francisco CA

Printed in the United States of America

Library of Congress Catalog Card Number: 2007923202

For all general information contact Arcadia Publishing at:
Telephone 843-853-2070
Fax 843-853-0044
E-mail sales@arcadiapublishing.com
For customer service and orders:
Toll-Free 1-888-313-2665

Visit us on the Internet at www.arcadiapublishing.com

In memory of Carlee Atkinson (1932–2003), Grosse Ile Historical Society president, board member, and tireless volunteer who first urged the society to consider Arcadia as our publisher; and in memory of Lois Howard, Gertrude Meagher, Violet Oldani, and Loretta Nankervis whose dedication to the historical society over many years helped make our work possible.

CONTENTS

ACKNOWLEDGMENTS

For many years we in the Grosse Ile Historical Society talked about publishing a book based on images in our archival collections. We considered finding someone more experienced to do the writing, but Anna Wilson at Arcadia urged us to do it ourselves and, to our own amazement, that is what we have done!

The core committee, led by Sarah Lawrence, consisted of Suzanne Ashley, Ann Bevak, Betty Blazok, and Clare Koester. We had help from Jacquie Cummings, Nancy Karmazin, Marc Lafayette, Carol Lantz, Joan Strickler, Joel Thurtell of the *Detroit Free Press*, and some U.S. Navy veterans formerly stationed on Grosse Ile. We are indebted to all of them plus the late Isabella Swan, whose authoritative book on the history of Grosse Ile, *The Deep Roots*, was our most trusted resource.

We wish to thank all those who responded to our call to lend images from their private collections. We have used a number of them. Images, except where noted, are from the collection of the Grosse Ile Historical Society.

We hope this book will provide information and enjoyment for current and former island residents for years to come—and for anyone interested in learning more about "Our Little Island, Grosse Ile."

INTRODUCTION

Grosse Ile is home to about 11,000 people who feel very fortunate to live on these beautiful and unique islands situated in the Detroit River south of Detroit. Grosse Ile is the name of the main island, but other smaller islands are also inhabited: Elba, Upper Hickory (Meso), Hickory, and Swan. Grosse Ile's main island is actually two islands created by the Thoroughfare Canal, which runs on a diagonal course from east to west. In all, more than a dozen islands comprise Grosse Ile Township, providing superior habitats for humans, birds, mammals, and fish.

Grosse Ile historians trace island history back to July 6, 1776, when the Potawatomi Indians deeded the land to prominent Detroit merchants William and Alexander Macomb. A monument commemorating the day the tribal chiefs and elders signed the deed is located on the river at the foot of Gray's Drive. The original deed is in the Burton Historical Collection, Detroit Public Library.

Three flags have flown over Grosse Ile—French, British, and American. The early French explorers identified the island as *la grosse ile* (the large island). The British, whose influence around Detroit became established in 1763, anglicized the spelling to Grosse Isle. This form continued until the early 20th century, when local residents persisted in an effort to reestablish the historical name. (Residents have been spelling and explaining the name Grosse Ile to out-of-town relatives and visitors ever since.)

Grosse Ile residents and visitors can travel to the island by land, air, and sea. Those who drive over must cross one of two bridges. The north end bridge is the privately owned Grosse Ile Toll Bridge, which opened in 1913 to traffic that included sheep and horse-drawn wagons as well as early versions of the automobile. The Wayne County Bridge (also known as the "free bridge") opened in the 1930s to accommodate the rapidly expanding island population.

If visitors come by air, they land at the Grosse Ile Municipal Airport at the south end of the main island. During the 1920s, this small airport was the scene of early aviation activities. Curtiss-Wright Aeronautical Corporation operated a flying school, and the first all-metal dirigible, the ZMC 2, was built for the navy in an enormous hangar. In 1927, work started on a navy seaplane base, and several years later the navy acquired a majority of the property. The site developed into a vital center for military flight training during World War II. In 1942, it was designated the U.S. Naval Air Station Grosse Ile and expanded considerably to accommodate large numbers of American and British fliers who trained on the island. Naval operations continued until the base was closed officially in 1969. The following year, it was deeded to the township and converted to civilian use.

Boats have been the favored mode of transportation to Grosse Ile's shores since the first humans plied the waters of the Detroit River. In the late 1800s, Sugar Island was an amusement

park and people traveled down the river from Detroit and other points on steam-powered paddle wheelers to enjoy a day at the park.

From the 1890s through the first half of the 20th century, all ships using the waterway between Grosse Ile and the Canadian shore were guided by a series of lights including the Grosse Ile Lighthouse. Established in 1894 at the north end of the island, the structure was rebuilt in 1906. Although the light was turned off in the 1940s, the lighthouse stands today as a sentinel of the river and a landmark for small boaters. An old kerosene lamp used before electrification—back in the days when the lighthouse keeper lived on Grosse Ile and kept the fire burning—is on display in the Grosse Ile Museum.

For about 50 years, visitors to Grosse Ile were able to come by train. From 1873 to about 1883, the Canada Southern Railroad carried both passengers and cargo from the mainland, over the railroad bridge (now the county bridge), across Grosse Ile (now Grosse Ile Parkway), and over a small bridge span that led to Stony Island. At that point, the cars were transferred to a ferry and taken to Gordon, Ontario, where they were put back on track to continue the journey to Buffalo. The old U.S. customhouse, which served the international route, now stands behind the museum and houses antique furniture, artifacts, and archives.

The Canada Southern went into receivership in the early 1880s and the Michigan Central Railroad took over. In 1904, the railroad built a new depot (our museum). The route to Canada was discontinued, but many residents used the commuter service to Detroit where they worked or attended school. Vacationers came to Grosse Ile by train to enjoy summer cottages, camping, or a stay at one of the resort hotels. The trains continued until the mid-1920s when the automobile became the preferred mode of travel.

Residents and visitors alike appreciate the architectural diversity of Grosse Ile. Although recent years have been characterized by ongoing new housing construction, there are many older homes located throughout the islands. Five homes, built in the 1840s to 1860s, are in the national historic district on East River Road at the Grosse Ile Parkway. A dozen 1920s-era homes, in an area known as Jewell Colony, are listed on the Michigan Register of Historic Places. They were built "to provide country living for professionals" and comprised the first planned subdivision on Grosse Ile. St. James Church, an 1867 Episcopal church built in part with funds provided by a freed slave, is on the National Register of Historic Places. A magnificent Tiffany window can be seen in St. James Chapel.

Several of Detroit's automotive pioneers had summer homes on Grosse Ile in the early 20th century. R. E. Olds (Oldsmobile) built a magnificent summer estate on Elba Island in 1916. His home has been converted to apartment living, but three other houses on his estate are now private residences. Charles and William Fisher (Fisher Body) built mansion-type summer homes at the north end of Parke Lane. One remains today. Gen. William S. Knudsen (General Motors) spent summers at an old remodeled farm home near the county bridge. It later became the clubhouse for Water's Edge Country Club, owned and operated by the township. In the 1920s, Henry Ford and his wife bought a substantial piece of land between West River Road and the Thoroughfare Canal. Although they never built a home, they did sell pieces of their property to Ford employees. One unique structure on the water, known as the Pagoda House, was built in 1939 by Ford's personnel director Harry Bennett.

Michigan historic site markers at the roadside point out several historic sites and homes on the island. One such marker on West River Road south of Church Road designates the home of descendants of the Macomb brothers who purchased Grosse Ile in 1776. The adjoining acreage, Westcroft Gardens, is a Michigan Bicentennial Farm. Operated by Macomb descendants, Westcroft comprises a botanical garden and nursery known for hybridizing and growing azaleas and rhododendrons. Grosse Ile's other historic centennial farm, no longer in operation, is now owned by the citizens and is a center for family recreation.

One

THE EARLY YEARS

Life was good for the earliest inhabitants of the regions surrounding Grosse Ile.

Belonging to the Algonquin linguistic group, the people thrived during the archaic periods from 10,000 to 3,000 B.P. (before the present). The waters, ideal for transportation, teemed with a wide variety of fish and waterfowl. Fish included the giant prehistoric sturgeon, pike, catfish, perch, and pickerel. The forests abounded in game such as deer, elk, muskrat, and beaver. In addition, they farmed simply and harvested fruits, nuts, and berries.

Early Europeans in the area included fur traders, from whom the Native Americans learned the value of animal skins, particularly beaver. The Grosse Ile area was the ancestral home of the Potawatomi tribes who were driven out by the Iroquois before 1650. The first missionaries and French explorers simply sailed through, although Fr. Louis Hennepin, Robert Cavalier Sieur de La Salle's chaplain and journalist, wrote a glowing impression of the Grosse Ile environs.

Following them, about 1703, Antoine de La Mothe Cadillac, echoed Hennepins's earlier views in this description sent to his superiors in Quebec:

The banks of the river are so many vast meadows. . . . These same meadows are fringed with long broad avenues of fruit trees. . . . On both sides of this strait lie fine, open plains where the deer roam in graceful herds, where bears, by no means fierce and exceedingly good to eat, are to be found, as are also the savory wild duck and other varieties of game. The islands are covered with trees; chestnuts, walnuts, apples and plums abound; and in season the wild vines are heavy with grapes of which . . . a wine . . . was not at all bad.

When the Macomb brothers arrived as traders in the Detroit area about 1767, they began acquiring properties on both sides of the Detroit River. Within 50 years after executing a deed for Grosse Ile with the Potawatomi chiefs, the island had progressed from four cabins noted in 1776 and seasonal Native American encampments to a thriving farming community with a gristmill, limestone quarry and kiln, cider press, fisheries, and even, briefly, a military stockade.

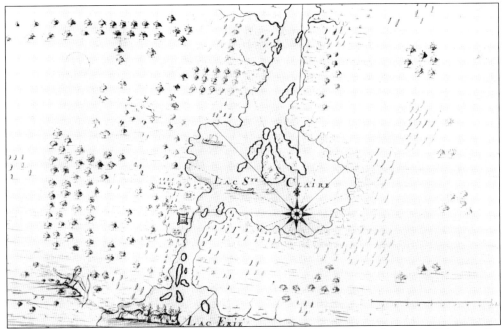

This undated "buffalo map," so called because of the Native American chasing buffaloes in the lower left corner, is one of the earliest rough maps of the Detroit River region. It shows Grosse Ile as the largest of the group of islands at the mouth of the strait, or river. The map may have been used by Antoine de La Mothe Cadillac in his report to his superior in Montreal, Count Pontchartrain. (Courtesy Burton Historical Collection.)

The earliest European interest in the Detroit River region came from coureurs des bois and voyageurs seeking furs. Detroit became a fur trade center for the region. Cadillac, Detroit's founder, fell into disfavor with Jesuit missionaries, and later with King Louis XIV, because he was known to trade liquor with the Native Americans to obtain furs. (Courtesy Burton Historical Collection.)

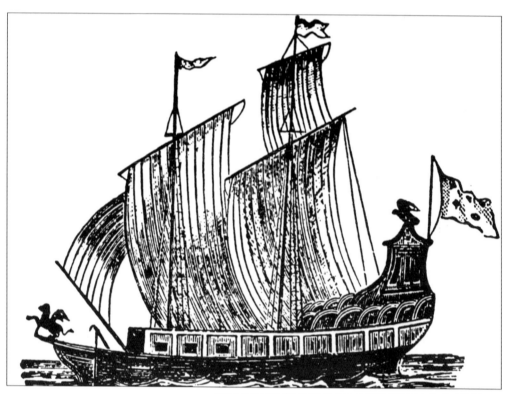

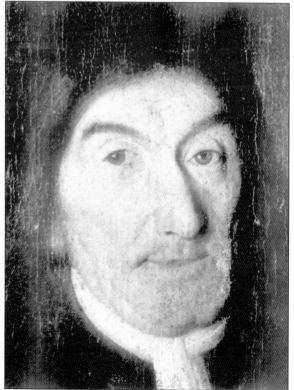

The two-masted, 50-ton sailing ship *Griffon*, skippered by Robert Cavalier Sieur de La Salle, was first to sail the Great Lakes. On August 10, 1679, his missionary-explorer-journalist, Fr. Louis Hennepin, recorded the views as they sailed up the Detroit River past Grosse Ile: "We came to anchor at the mouth of the strait that runs from Lake Huron to that of Erie. . . . That country is stocked with stags, wild goats and bears. . . . The forests are chiefly made up of walnut trees, chestnut trees, plum trees and pear trees." However, Hennepin's journals, full of exaggeration and misinformation, earned the disfavor of King Louis XIV of France who ordered him arrested if he set foot in France again. The ill-fated *Griffon* disappeared, returning from the Wisconsin region with a load of furs, but neither La Salle nor Hennepin were aboard. (Hennepin portrait courtesy Minneapolis Public Library.)

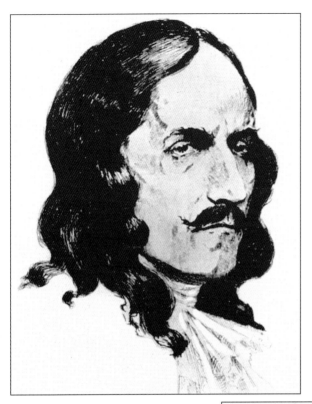

Recognizing the strait between Lake Huron and Lake Erie as a strategic location to protect French trading interests in the Great Lakes area, in 1700, King Louis XIV directed Antoine de La Mothe Cadillac to establish a colony there. Cadillac sailed by Grosse Ile on July 23, 1701, and sent a glowing description to his superiors, but a shortage of timber influenced his decision to build at present-day Detroit. (Courtesy Burton Historical Collection.)

This early map of the Detroit River names the islands at the mouth of the river: Isle aux Bois Blancs (Bob-Lo), Isle a la Pierre (Stony), and La Grande Isle (Grosse Ile). The engraved original is in Bellin's *Petite Atlas Maritime*, published in Paris, 1764.

LA RIVIERE DU DETROIT
Depuis le Lac Sainte Claire
jusqu'au Lac Erie
Echelle de Deux Lieues Communes

LAC ERIE

Alexander and William Macomb arrived in the Detroit area around 1767, having learned the trading business from their father, John. Their extensive enterprises included acting as sutlers to the British army, importing, and banking. They acquired properties on both sides of the Detroit River and early became interested in Grosse Ile. Pictured here is Alexander; no portrait of William is known to exist.

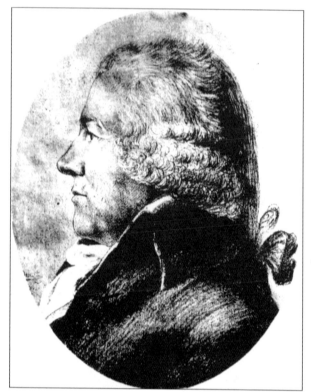

The deed for Grosse Ile (also called a treaty) between the Macomb brothers and 18 Potawatomi chiefs was executed on July 6, 1776. In 1906, a monument was dedicated at this site commemorating the event. The Macomb brothers assumed that they were "purchasing" the island, but native culture looked upon such treaties as permission to share the land. The original treaty tree was destroyed by lightning in 1902. (Courtesy Burton Historical Collection.)

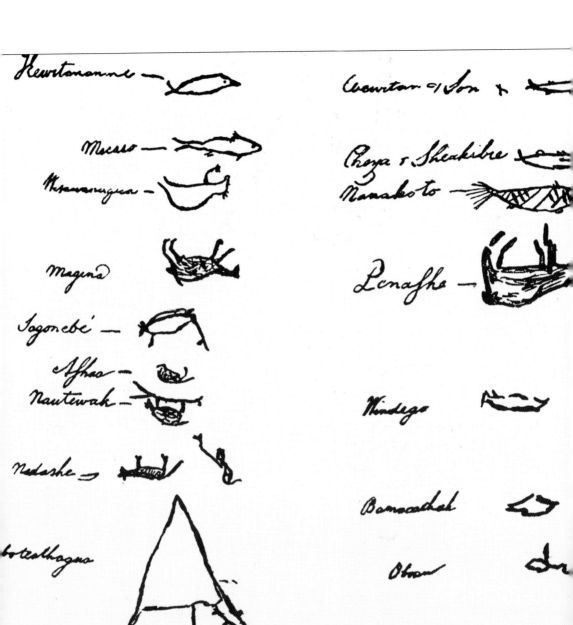

By their totems and thumbprinted wax seals, the Potawatomi chiefs and their eldest sons conveyed Kitche-minishen (the Potawatomi name for Grosse Ile) to the Macomb brothers. The original parchment is in the Burton Historical Collection at the Detroit Public Library. Some have said that upside-down totems were drawn from opposite sides of the conference circle. The seals have since worn off. The totem at lower left does not appear on the registered copy, which was filed with the Wayne County Land Records in 1819. Some Macomb descendants have claimed that this totem is the first representation of the American eagle. After the British acquisition of territories as a result of the French and Indian War, negotiations directly with Native American tribes were considered the prerogative only of the Crown. However, a similar treaty was arranged at about this same time for the area now known as Ecorse and Lincoln Park. The brothers knew that it was vital to prove residency and improvement of the land and set about accomplishing that immediately.

Thumb Prints.	Totems—"Seals" O	Thumbs of eldest sons of Chiefs.
O	1 Ke-wi-ta-na-wee—Fish	O
O	2 Micaro—Fish	O
O	3 Wi-sa-wa-na-qua—Bear.	O
O	4 Ma-qi-na—Doe deer.	O
O	5 Sagonebé—Faun with one leg.	O
O	6 Donaa—Little animal.	O
O	7 Mautewa—Apassum or limb of tree.	O
O	8 Nadase—Wild cat.	O
O	9 Wabatiatiagua—Tepee or tent.	O
O	10 Wawialia—Fish.	O
O	Hiakiba, son.	O
O	11 Areya—Fish.	O
O	12 Na-tu-at-a-loe—Large fish.	O
O	seal O	O
O	13 Wabo-ge-gua—Bear.	O
O	14 Pena-ku—Fish.	O
O	15 Wendigo—Fish.	O
O	16 Ba-na-ca-thaik—Fish.	O
O	17 Aboan—lake & hill.	O
O	18 Manaquang—Rude sketch of the American Eagle. (The first American Eagle ever seen portrayed on any occasion.) Statement of Commodore David Belton Macomb who now owns and holds the original Deed to Grosse Ile—A parchment of about 24 inches.	O

A booklet printed by the Women's Improvement Association of Grosse Ile following the 1906 dedication of the Treaty Tree Memorial Tablet provided a copy of the day's program. Speakers that day included two Macomb descendants and Clarence Burton, president of the Michigan Historical Society. It also listed each chief's totem in the Potawatomi language with a translation into English.

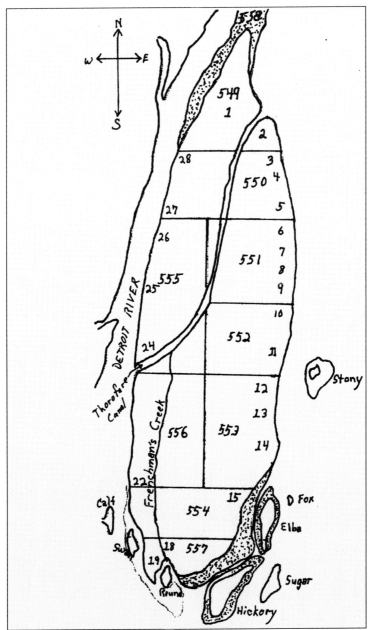

In order to cement their holdings on Grosse Ile, the Macomb brothers leased property to tenant farmers. Some were British loyalists waiting for land on the Canadian side of the river. Others were ransomed from the Native Americans following the French and Indian War. The above map shows both the private claims 549 to 557 established in 1885 by the U.S. Land Commission, as well as the lot numbers awarded to tenants (see page 17).

GROSSE ILE TENANT FARMS of William Macomb

Private Claim 549:
> Lot 1– Thomas Williams
> William Serret
> Justice Allen
> Jesse Hicks (1803)
> Lot 2– Mill Property

Private Claim 550 (East Side):
> Lot 3- Elisha Horn
> Martin T. Meyer (Toffelmeyer)
> William Gifford

John Wert (Wart, Wirt)
> Lot 4- Leonard Kratz (Scratch)
> Macomb Mansion House
> Lot 5- Charles Munger
> Edward McCarty
> James Anderson
> Joseph Bareau

Private Claim 551:
> Lot 6- Peter Malott
> Lot 6- John Cray
> Lot 8- William Lockart
> Lot 9- John & Robert Jones
> John Johnston

Private Clain 552:
> Lot 10- Lime Kiln Lot
> Jacob Iler
> James Mitchell
> Lot 11- Robert Gill
> Martin Theophilus Myer (Meyer)

Private Cleaim 553:
> Lot 12- Philip Fuchs (Fox)
> Lot 13- [John] Snyder
> Lot 14- John Hembrow (Embro,
Hembro)
> Jacob Dix (Dicks)
> Jacob Stoffer

Private Claim 554:
> Lot 15- Henry Crow
> Elisha Horn
> Jacob Stoffer
> John Jackson

Private Claim 557:
> *Lot 18- John Baptiste Dubois
> (at Frenchmans's Creek)
> *Lot 19- Joseph Ferris Jr.

Private Claim 556:
> *Lot 22- [Charles] Munger
> James Mitchell
> Michael Myers
> Adna Heacock (Heacok, Hecox, Hickock)

Private Claim 555:
> *Lot 24- John Ireland
> Robert Gill
> *Lot 25- John Hartley Sr.
> *Lot 26- John Hartley Jr.

Private Claim 550 (West Side):
> *Lot 27- Henry Hoffman
> Adna Heacox
> James Chittenden
> Lot 28- Joseph Ferris Sr.
> Robert Gill
> * location indefinite

The first tenant farmer was Thomas Williams, of record on lot 1 in 1784. The first ransomed settlers were the widow Sarah Malott and her son Peter (lot 6). Farmers paid rent and/or ransom in bushels of grain or shares of increased livestock. The first year's rent was waived if the farmer built a home. Produce included potatoes, onions, and squash. Livestock included chickens, cattle, hogs, and sheep. Abundant game came from hunting and fishing, and a harvest of fruits and nuts added variety to the settlers' diet. Native Americans bartered maple sugar for meat and grain. Encounters with the Native Americans were not always peaceful as livestock and equipment were often pilfered.

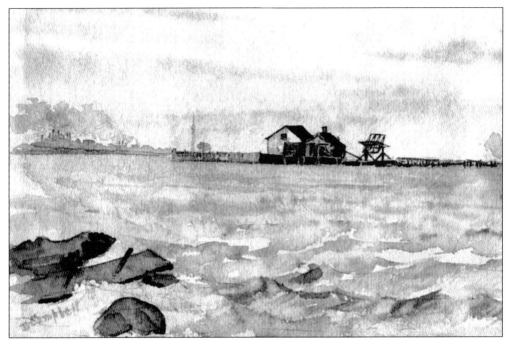

This watercolor painted in 1891 by Douglas Campbell, a relative of early island residents Samuel T. Douglass and his family, illustrates one of several fisheries located on the islands at the mouth of the Detroit River. Commercial fishing for whitefish and sturgeon thrived in the early 1800s. One report of October 26, 1821, states that 16,000 whitefish were taken by two seines in 12 hours.

A fort (also called a stockade) was established in 1815 on the east side of Grosse Ile, ostensibly for protection from the Native Americans. However, in her book *The Deep Roots*, Isabella Swan was of the opinion it was built to thwart British efforts to exercise control over the island. After the fort was abandoned in 1819, John Rucker, who owned the land, moved into the barracks with his family and lived there until 1835.

Two

THE MACOMB LEGACY

After receiving their deed for Grosse Ile, Alexander and William Macomb took several steps to solidify their claim. They agreed that William would hold their property in Michigan (still under control of the British Crown), and Alexander would move to New York and ally himself with the new American nation. William built a "mansion house" on Grosse Ile (so called because it belonged to the land owner) and occupied it occasionally, even though he was still a resident of Detroit. He secured tenant farmers to live on the land, build houses, and raise crops. He also built a gristmill, a cider press, and a wharf on the mill property. After the establishment of the Michigan Territory in 1885, the U.S. Land Commission divided Grosse Ile into nine private claims, numbers 549 through 557, which are still in use to describe island property.

In New York, Alexander owned a fleet of merchant vessels. He was initially successful but suffered financial reverses and was forced to release his Detroit interests including Grosse Ile to William for £200. He died in Georgetown, D.C., in 1831. Alexander married twice: Catherine Navarre in 1773 and Jane Marshall Rucker in 1791. His son Gen. Alexander Macomb later married his first cousin, William's daughter Catherine, and some of their descendants live on Grosse Ile to this day (2007).

William, who had married Sarah Jane Dring in 1780, died in 1796, and his widow moved to New York to better educate her eight children all under the ages of 15. She left her estate under the management of Angus Mackintosh and the lawyer Solomon Sibley, who filed claims on behalf of John W., William II, and David Macomb, William's surviving sons, and eventually secured clear title to their Grosse Ile lands.

John W., who died in 1815, and his brothers were pressed by creditors and were eager to sell some of their Grosse Ile properties. Gen. Alexander Macomb purchased Elba Island, and in 1819, John Anthony Rucker, who had married Sarah Macomb, the brothers' sister, purchased at auction 11 lots on Grosse Ile in what later became private claims 552–554.

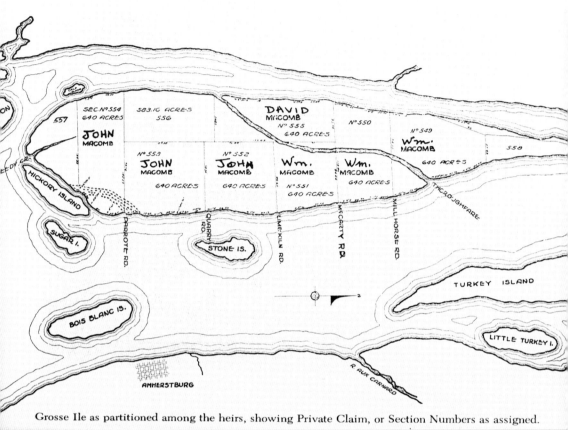

Grosse Ile as partitioned among the heirs, showing Private Claim, or Section Numbers as assigned.

Solomon Sibley, who was handling legal affairs for the estate of William Macomb, managed to secure clear title to their Grosse Ile lands for William's sons John W., William II, and David. This map, from *The Deep Roots*, shows the division of land among the three sons around 1815.

William Macomb II married Jeanette Marentete in 1816. They had four children: Archange, Sarah Jane, William Francheville, and Catherine. Following their mother's death in 1852, the three daughters inherited the mansion house land, private claim 550. They became progenitors of many generations of Grosse Ile residents.

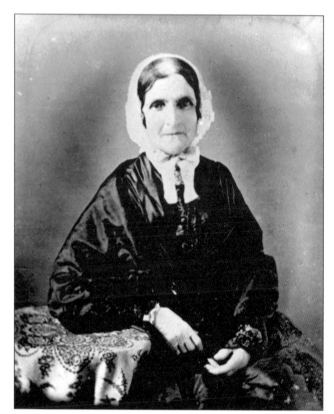

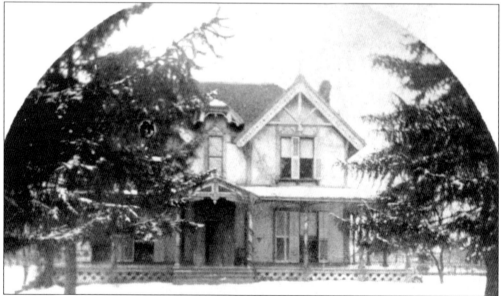

Archange inherited the second Macomb mansion house, which her father, William II, had built in 1817 on the southernmost parcel of private claim 550. In 1849, she married Thornton Fleming Brodhead, and they raised their six children in this house. Archange died in 1891, but two of her daughters, both maiden ladies, continued to live in the house until it burned in 1921. (Courtesy Burton Historical Collection.)

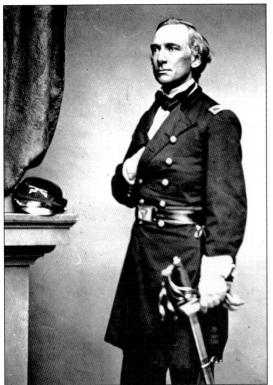

Thornton Fleming Brodhead was, in the 1850s and 1860s, at various times part owner and editor of the *Detroit Free Press*, postmaster in Detroit, and a state senator. Since he had previous military experience, at the beginning of the Civil War he was made a colonel and placed in command of a cavalry regiment mustered in Detroit. He was mortally wounded at the Second Battle of Bull Run and died in 1862. (Courtesy Burton Historical Collection.)

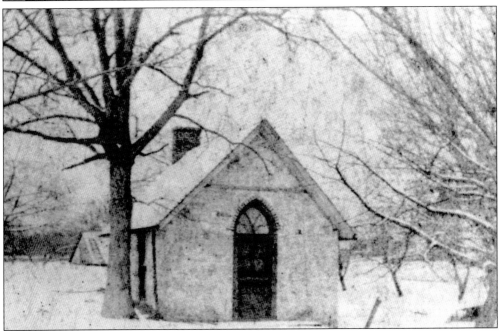

About 1855, Brodhead built this small office just south of his mansion house home as a place he could work without household interruptions. The office still stands in front of a home on East River Road, although it no longer has a roof. The office was designated as a Michigan historic site in 1980. (Courtesy Burton Historical Collection.)

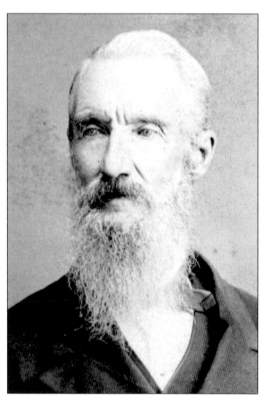

Catherine (pictured below), a second daughter of William Macomb II and Jeanette Marentete, married John Wendell in 1841. John was from Washington County, New York, where he had been born around 1818. Catherine and five children appear on the 1860 U.S. census for Detroit, but by 1870 the family (including John) had moved to Grosse Ile. He is listed as a farmer, and the couple had seven children: Oscar, Catherine, Mary, Jeanette, Susan, Edith, and Leila. Sarah Jane Macomb, the third daughter of William II to inherit part of the mansion house property, received the northernmost parcel. She married Henry Navarre Brevoort and, after his death in Detroit in 1851, moved to Grosse Ile with her three children.

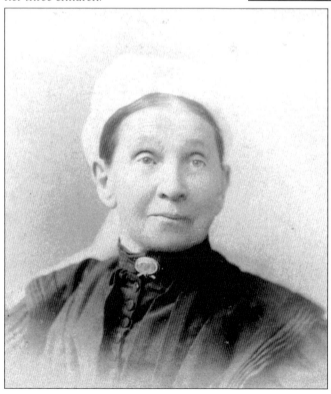

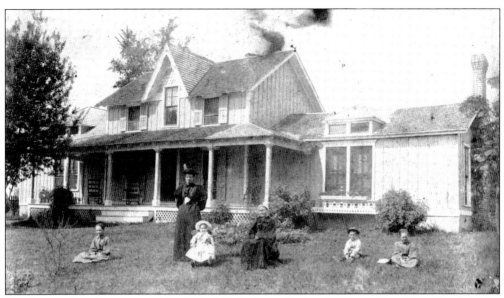

The home of Catherine and John Wendell, built in the late 1860s on East River Road, is the only home of the three Macomb daughters that remains standing. Its Gothic frame construction is typical of the time. Catherine is shown seated, and her daughter Edith, who married John Henderson, is standing in this c. 1892 photograph. Seated beside Edith is her son Oscar; his brother Wendell (at right) is wearing a hat. The two girls are their cousins Edith and Catherine Bury.

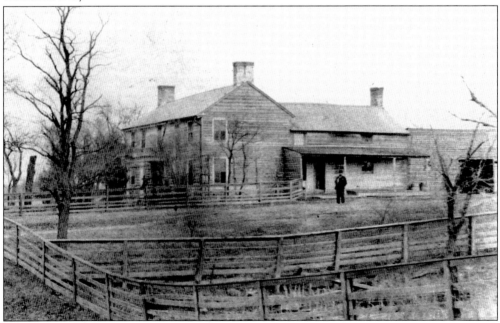

John Anthony Rucker married the first William Macomb's daughter Sarah and brought her to live on Grosse Ile in 1819. The family lived in the barracks of the abandoned fort until 1835 when Rucker acquired the west side James Chittenden property. The log house that Chittenden had built around 1816 stands at West River Road and Byromar Lane. Now sided, it is recognized as the oldest building on the island. (Courtesy Burton Historical Collection.)

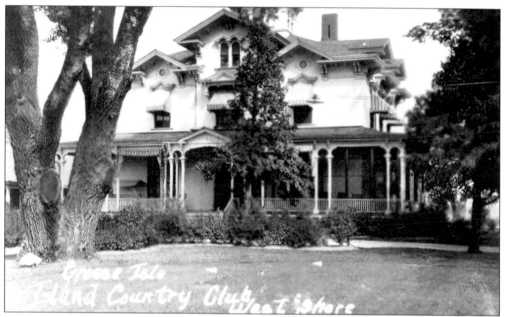

In about 1875, L. S. D. Rucker, son of John and Sarah, built this home on west side acreage he had recently purchased. When the farm was later sold and became the West Shore Golf and Country Club, this house served as the first clubhouse. The house was demolished in 1971.

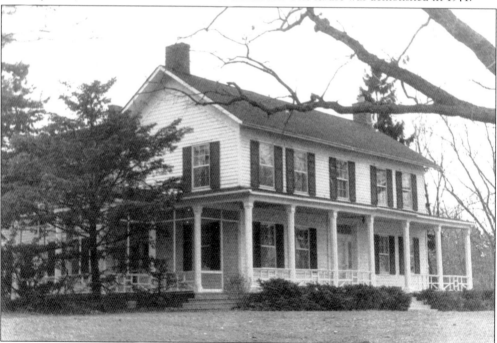

Another resident on the west side with Macomb connections was Robert Lee Stanton. He was the son of Alexandrine Macomb, whose parents were both descendants of the original Macomb brothers. John Anthony Rucker Jr. built this house about 1835 and sold it and the 100-acre farm to Robert Lee Stanton in 1873. The house is still occupied by his descendants, and the farm, Westcroft Gardens, is a Michigan Bicentennial Farm.

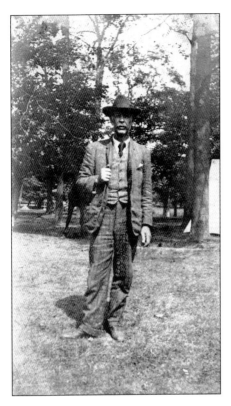

Robert Lee Stanton was the son of U.S. Army general Henry Stanton and was named for his father's friend Robert E. Lee. In 1889, he married Grace Newman and brought her to live on Grosse Ile. They had three children: Madeleine, born in 1890; Ernest, born in 1892; and Henry, born in 1894. Robert was active in island affairs, serving as school trustee, justice of the peace, and member of the township board. He was also active in St. John's Episcopal Church, which stood on the northwest corner of his farm. But primarily he was a farmer, growing hay for the horses that pulled Detroit's trolley cars. In these pictures, taken about 1905, Robert and Grace are shown during a camping trip they took with their family to the southern end of Grosse Ile. (Courtesy Richard White.)

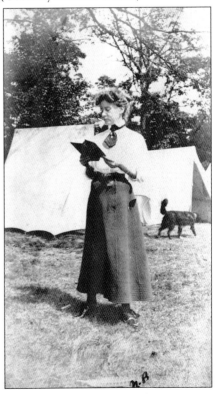

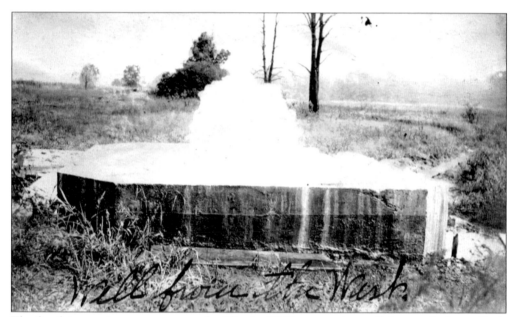

The family's camping spot was near the Wonder Well, an artesian well dug on the Louis Groh farm in 1903 in the hope of finding oil. No oil was found, but the Groh family later developed the Wonder Well into an attraction, which, for many years, drew visitors to sample its mineral water. (Courtesy Richard White.)

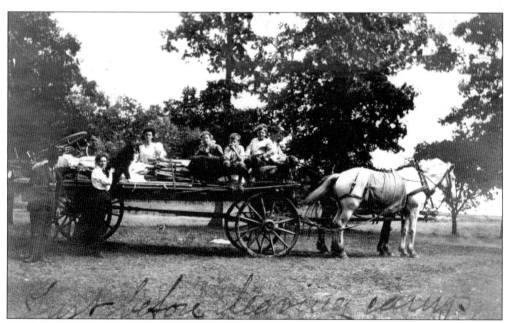

For their camping trips, the Stantons loaded themselves and their dogs with their camping and recreational gear onto a large horse-drawn farm wagon and traveled the three or four miles south on West River Road to their camping site. (Courtesy Richard White.)

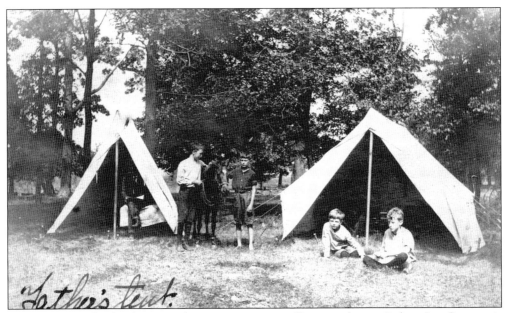

Once at camp, the family set up their tents near a small grove of trees. Robert Lee Stanton is seen sitting in his tent, and the two boys seated in front of the second tent are probably Henry and Ernest Stanton. The other boys may be neighbors who have brought their pony over for the children to ride. (Courtesy Richard White.)

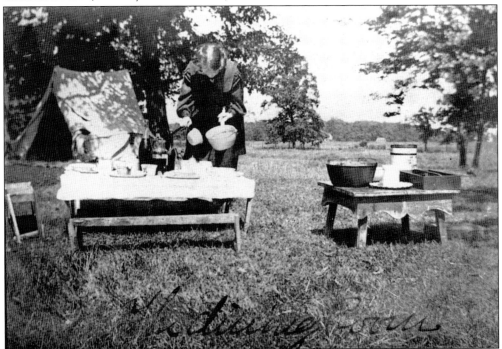

The family was not deprived of all the comforts of home while camping. This may be Lydia Merrick, the family's cook listed on the 1900 U.S. census, who is serving up a meal she had probably cooked over a campfire. The wooded rise seen in the distance is probably Round Island. (Courtesy Richard White.)

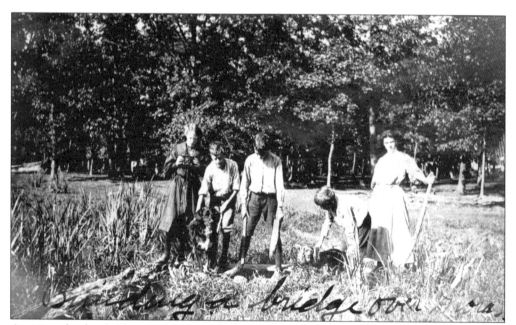

Activities for the children at camp must have been limited. Here they are seen "building a bridge over [a] morass." The woman overseeing the work may be Mary Adams, another household servant. Madeleine is at left holding a camera, while her brothers and a friend survey the building project. (Courtesy Richard White.)

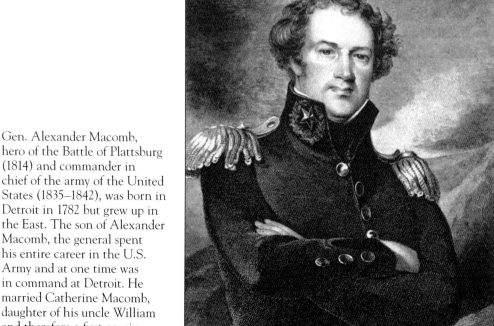

Gen. Alexander Macomb, hero of the Battle of Plattsburg (1814) and commander in chief of the army of the United States (1835–1842), was born in Detroit in 1782 but grew up in the East. The son of Alexander Macomb, the general spent his entire career in the U.S. Army and at one time was in command at Detroit. He married Catherine Macomb, daughter of his uncle William and therefore a first cousin.

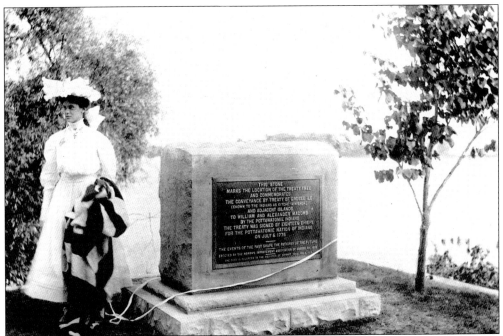

Madeleine Stanton, as a descendant of both William and Alexander Macomb, was given the honor of unveiling of the Treaty Tree Memorial Tablet in 1906. The ceremony, organized by the Women's Improvement Association, marked the 130th anniversary of the Macomb brothers' treaty with the Potawatomi Indians. For the occasion a sapling—said to have been taken from the original treaty tree—was planted overlooking Gray's Landing and the Detroit River. (Courtesy Richard White.)

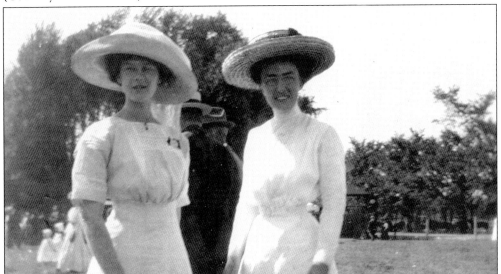

Madeleine is shown here about 1910 with Irene Crosby, another Grosse Ile resident. The occasion is probably a farmers' fair organized by the Grosse Ile Farmers' Club for the purpose of displaying the members' agricultural products. Robert Lee Stanton was a founder of the Farmers' Club and its annual fairs, held on the country club property north of St. James Episcopal Church, always drew large crowds.

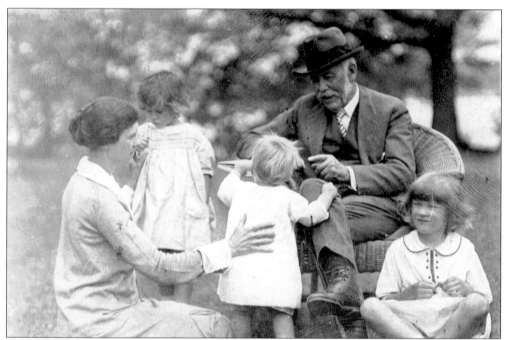

Madeleine married Kenneth T. White and had three children, Madeleine (seated at right), Sonia (standing), and Richard (Dickie). She is shown here about 1925 visiting with her father, Robert Lee Stanton, at his home on Grosse Ile. Richard White is one of just a few Macomb descendants still living on Grosse Ile. (Courtesy Richard White.)

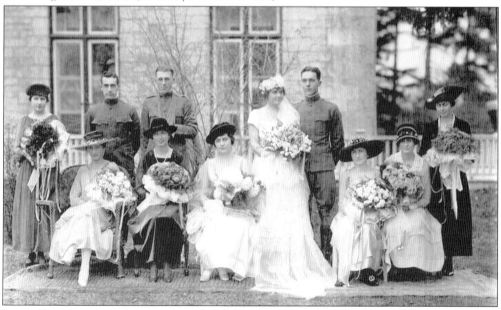

Ernest Stanton married Constance Blauvelt in 1917. The Blauvelts, longtime island residents, lived in the Anthony Dudgeon house on the corner of East River Road and Grosse Ile Parkway where this picture was taken. Included in their wedding party were Eleanor Clay (Ford), standing at left; Kenneth White (brother-in-law of the groom), second from left; Helen Blauvelt (sister of the bride), seated third from left; and Grace Scott (Wright), seated second from right.

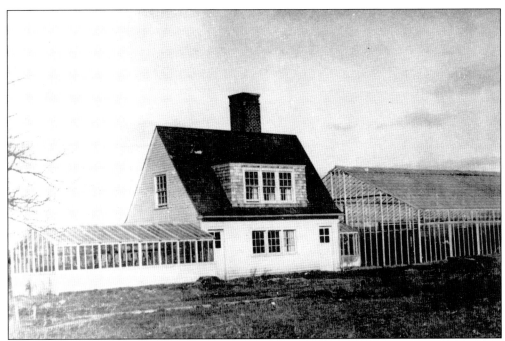

When Ernest Stanton returned from service in Europe after World War I, he was advised by his doctors to seek outdoor work. Under his management, Westcroft Gardens was gradually turned from treeless hay fields into a nursery specializing in acid-loving plants. He hybridized rhododendrons and azaleas and became known throughout the country for developing strains that could withstand cold midwestern winters. The five and one half acres of landscaped display garden he laid out have been enjoyed by countless visitors over the years. Today the farm is operated as a nursery by Denise deBeausset, Ernest Stanton's granddaughter and a seventh-generation descendant of the Macomb brothers. These two pictures show the barn, office, and greenhouses at Westcroft as they appeared about 1925. (Courtesy Constance deBeausset.)

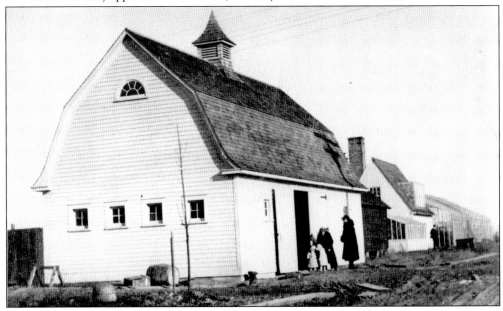

Three

RAILROADS, HOTELS AND SUMMER RESORTS

The coming of the railroad to Grosse Ile in the 1870s brought about many changes for the island. In what had been primarily a residential and farming community, the railroad opened up the possibility of easy access to the island for vacationers seeking relief from the city's heat and congestion. It also gave island residents better access to opportunities in the city for work and school. Hotels, boardinghouses, and rental cottages were built to attract summer visitors and provide them with outdoor recreational activities.

The Canada Southern railroad was first to arrive on Grosse Ile. Seeking to link the lucrative markets of the East Coast with agricultural products from the West, the Erie and Niagara Railway planned a route across southern Ontario that would eventually reach Chicago. Renamed the Canada Southern Railway, eastward construction was begun in Fort Erie, Ontario, and westward construction in Amherstburg, Ontario. The last spike was driven at Townsend, Ontario, in 1873. A bridge or tunnel was originally envisioned to cross the Detroit River at Amherstburg, but those plans were abandoned in favor of crossing the river using a combination of bridges and ferries. A bridge was built to Grosse Ile from Slocum's Junction, south of Trenton, and a trestle from Grosse Ile to Stony Island. From there, railcars were carried to Gordon, Ontario, aboard the ferry *Transfer*. By 1880, extensive rail yards had been built south of the tracks crossing Grosse Ile. The railroad's numerous employees were housed in hotels and boardinghouses on the island. Passenger and freight service continued on this line for a few years, but ice on the river proved to be troublesome, and by the end of 1882, the railroad had built an alternate route with a ferry crossing at Windsor. By 1888, the Grosse Ile crossing had been abandoned.

The Canada Southern's plans to continue building their rail line on to Chicago were never realized. Economic conditions intervened, and building was brought to a stop at Fayette, Ohio, on the Michigan border. The rail yard facilities on Grosse Ile were closed, and the Michigan Central Railroad took over rail service to the island. Daily passenger service was discontinued in 1924.

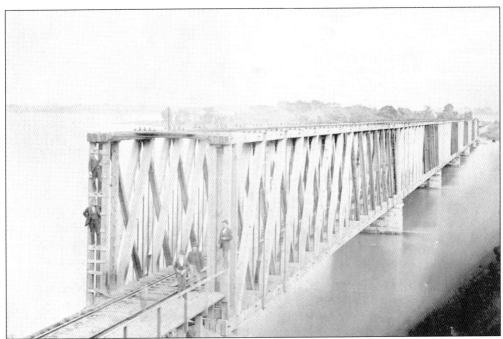

As part of their planned through line from Buffalo to Chicago, the Canada Southern Bridge Company, a subsidiary of the Canada Southern Railway, built this timber and steel trestle between Grosse Ile and Stony Island, seen in the distance. Apparently the trestle had just been completed when officials of the railroad and the contractor posed for this picture in 1873.

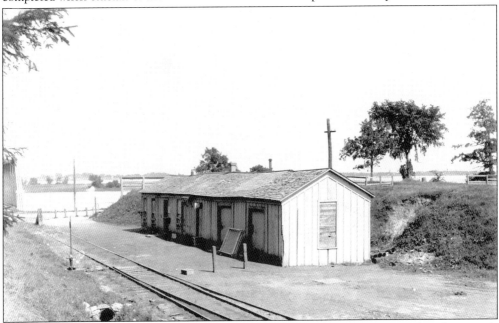

The Canada Southern depot on Grosse Ile is shown as it looked about 1900 in this photograph by the Detroit Publishing Company. Built about 1873, it was now beginning to look rather derelict. The view is southwest toward the Detroit River. The railway trestle to Stony Island is just visible at the far left.

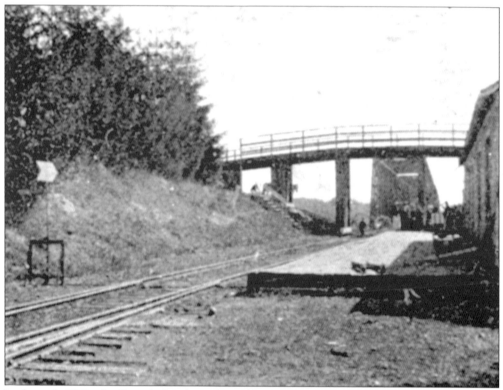

In the early 1870s, the Canada Southern depot (far right) is shown with a platform and passengers at the far end waiting for the train. A bridge carried traffic on East River Road over the tracks, and a wooden stairway provided access to the depot from the road above.

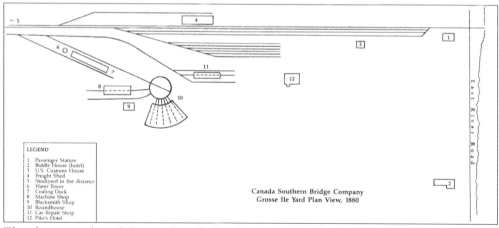

LEGEND
1 Passenger Station
2 Biddle House (hotel)
3 U.S. Customs House
4 Freight Shed
5 Stockyard in the distance
6 Water Tower
7 Coaling Dock
8 Machine Shop
9 Blacksmith Shop
10 Roundhouse
11 Car Repair Shop
12 Pike's Hotel

Canada Southern Bridge Company
Grosse Ile Yard Plan View, 1880

This drawing, adapted from a Canada Southern Railway blueprint, shows the rail yard near the center of the island just south of the tracks. Buildings there included a roundhouse and repair shops as well as a U.S. customhouse. The many single men employed by the railroad stayed at Pike's Hotel, the Biddle House, and a number of other boardinghouses located near the main line.

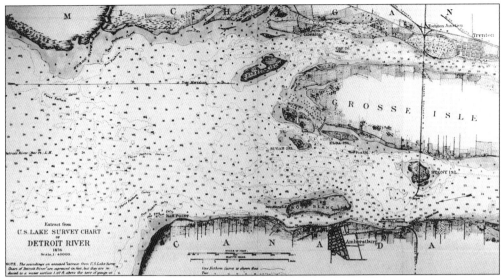

This U.S. Corps of Engineers chart, created in 1876, clearly shows the route of the Canada Southern rail line from Trenton (or Slocum's) Junction across Grosse Ile and on to Stony Island. At the end of the line, railcars were loaded onto ferries for the journey to a dock at Gordon, Ontario, just north of Amherstberg.

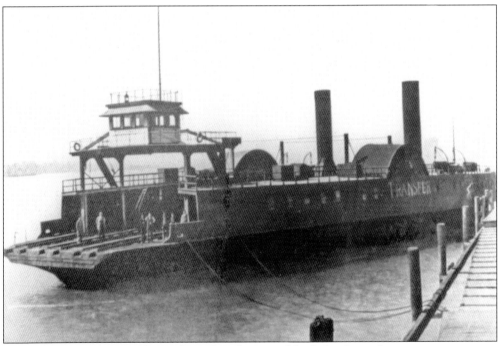

The Canada Southern Railway's ferry *Transfer* carried both freight and passenger cars across the main channel of the Detroit River. It was joined in 1880 by a second ferry, the *Transport*. However, ice in the channel caused repeated disruptions of service, and in 1883, the Canada Southern rerouted its main line from Essex Center, Ontario, to Windsor. The Stony Island to Gordon route was completely abandoned in 1888. (Courtesy Fort Malden Museum.)

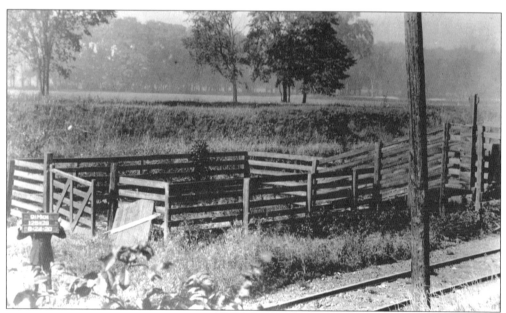

Never strong financially, the Canada Southern was absorbed into the Michigan Central Railroad system, which, in 1920, conducted a survey of all their railroad facilities including those on Grosse Ile. These cattle pens, which stood on property now part of the Grosse Ile Golf and Country Club, had been used by the Canada Southern in the 1870s and 1880s to give animals a break during their long train journey. The survey also photographed this engine house, where the Michigan Central locomotive was housed overnight to be ready for the first run to Detroit the following morning. After the through line across Grosse Ile to Buffalo was abandoned, the Michigan Central began running an "accommodation train" from Grosse Ile to Detroit, serving businessmen going to work in the city and students attending high school there.

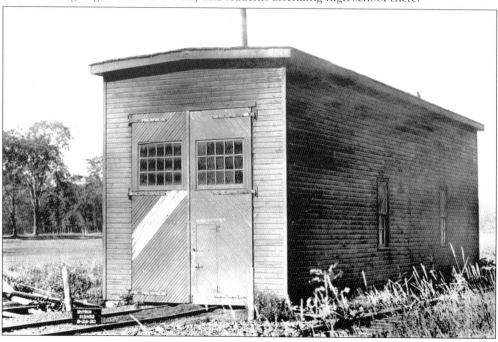

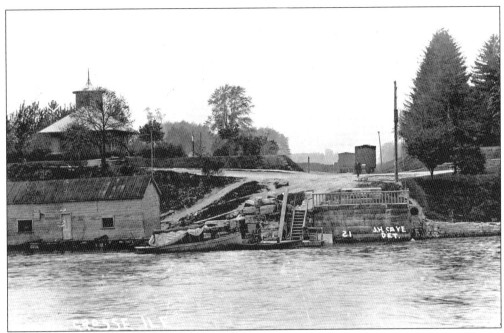

Taken about 1910, this postcard view shows the new depot and water tower built in 1904 by the Michigan Central Railroad. They stand on the hill just south of the former main line and old depot (now demolished). The first section of the railroad trestle to Stony Island has been removed, but the stone abutment, which anchored it, can still be seen in the foreground.

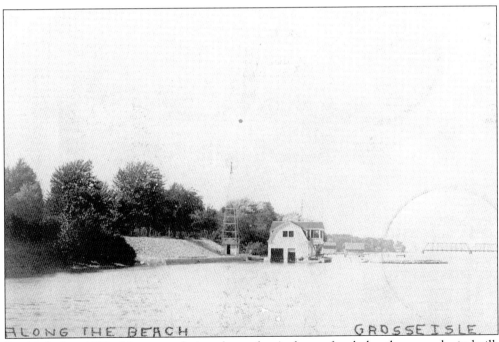

Postmarked in 1908, this postcard view shows the Atcheson family boathouse and windmill, which stood on East River Road just north of what is now Manchester Road. The railroad trestle is visible in the distance with the first span having already been removed.

Looking north from in front of the new Michigan Central Railroad depot about 1910, a wooden barrier marks the spot where the rail line had once crossed East River Road, but no other vestiges of its former presence remain. The steps at left lead down the hill from the depot.

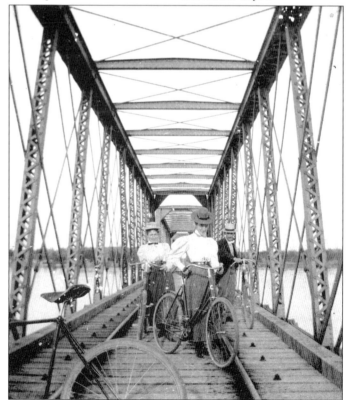

The railroad bridge to Grosse Ile provided the first opportunity (except in winter) for walkers and bicyclists to reach the mainland from Grosse Ile without going by boat. This group, enjoying an outing about 1890, includes, from left to right, Lizzie Fairchild, Ada Sunderland, and Wesley Bowbeer.

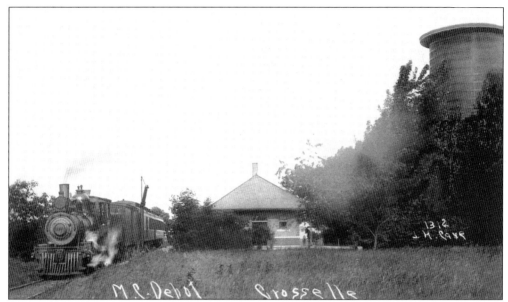

The Michigan Central Railroad depot was the end of the line for travelers to and from the mainland. The train apparently backed into the station on a spur from the old Canada Southern main line, which brought it to this location next to the new depot.

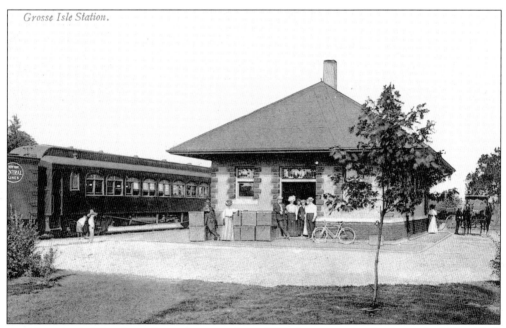

Grosse Isle Station.

Another view of the depot from the west about 1910 shows a train clearly marked New York Central Lines, of which the Michigan Central was a subsidiary. A group standing in the doorway to the baggage room includes Frederick and Marie Burdeno, whose son Norbert is the child wearing the tall hat. A horse-drawn carriage, such as the one in the driveway, provided rail passengers transportation to and from the station.

After daily rail passenger service to Grosse Ile was discontinued in 1924, the depot was used for other purposes including, in this view, a branch of the Wayne County Library. The area through the door at the right probably led to the former station master's office. Here he would have sold tickets through the grilled opening above the desk and watched for trains from the bay window, which juts out on the north side of the depot.

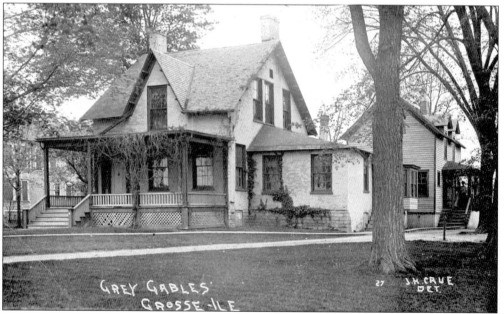

One of the earliest hotel proprietors on Grosse Ile was Horace Gray. He came to Grosse Ile in 1846 and settled on the southern half of private claim 552. He built this home about 1847. Later he and his wife operated a boardinghouse there for summer visitors to the island, since many of the tour boats bringing visitors arrived at what was known as Gray's Landing.

Horace Gray was born in Waterford, New York, in 1812. He married Frances Bury, daughter of the Reverend Richard and Marietta Bury. In order to supplement farm income, Horace became a government agent to the Dakota Indians in 1859, leaving Frances at home to manage the farm and boardinghouse. During the Civil War, he joined the Michigan 4th Cavalry with the rank of major. He died in 1895.

Marietta "Miss Ettie" Gray was born in 1847, the second daughter of Horace and Frances Gray. Neither she nor her older sister Frances "Miss Fannie" ever married. Miss Ettie served for many years as the island's postmistress, and Miss Fannie taught in the island schools. After their father's death, they both helped their mother run the boardinghouse Gray Gables.

The Reverend Richard Bury purchased the northern half of private claim 552. He and his wife, Marietta, with their three sons and two daughters, moved to Grosse Ile the same year as the Grays. To help meet mortgage payments, the Burys began taking in lodgers. Their eldest son, William, ran the farm and hotel while Richard pursued his church work. Their hotel, called the Island House, burned in 1861.

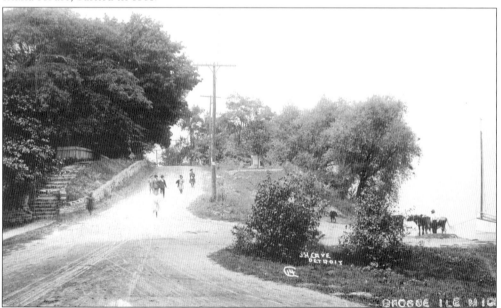

Gray's Landing is shown here as it appeared about 1910. Horace Gray's dock is gone, but the landing is still being used for beaching small boats and watering cattle. A group of children, possibly heading home from school, can be seen walking down the dirt road past the Treaty Tree monument. The stone steps at left led to the Lyon farm, formerly the site of the Burys' hotel.

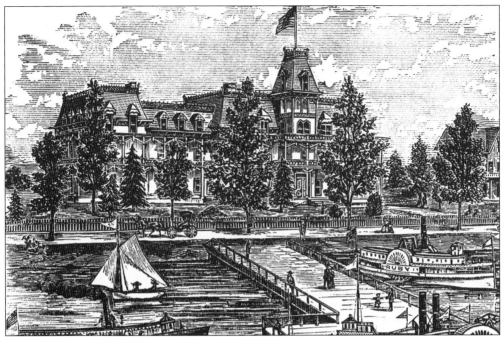

With the coming of the railroad to Grosse Ile, a group of investors, including George A. Alexander, felt it was time Grosse Ile had a real resort hotel. In 1874, they opened a luxury hotel on land owned by Alexander just north of the old mill property (now Lighthouse Pointe). Called the Alexander House, it became "the show place of Grosse Ile." It offered swimming, boating, fishing, and small game shooting and hosted dances in its large dance hall. To accommodate its many guests, the hotel operated an omnibus and dray to pick up those arriving by boat, ferry, and train. In addition, William S. Biddle provided transportation in his family's horse-drawn bus. After only a few short years of operation, the Alexander House was destroyed by fire in 1880.

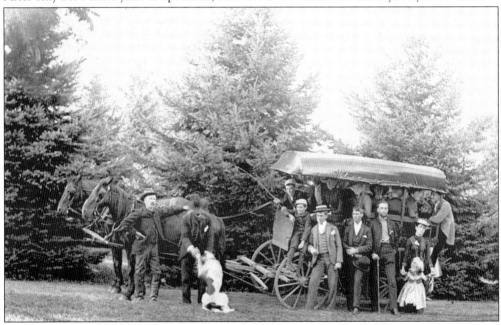

The Reverend Moses Hodge Hunter came to Grosse Ile in 1847 to establish a boarding school for boys. This building, located on the site of the present St. James Episcopal Church, served as both his home and school until 1861 when Hunter left to join the army. The home was later sold to James Biddle, one of Hunter's former students, who is responsible for building the stone fence. (Courtesy Burton Historical Collection.)

The Canada Southern Railroad purchased James Biddle's house around 1874 to accommodate some of its employees. They called it the Biddle House and may have built the addition shown here. The Canada Southern also operated Pike's Hotel near the depot. The 1880 U.S. census shows 14 railroad employees boarding at each of these hotels plus several more at other locations. Occupations of the men included machinist, carpenter, and boiler mender.

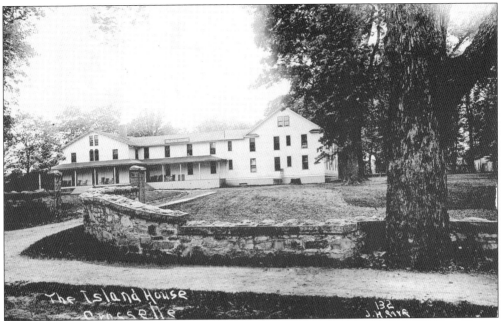

After the Michigan Central Railroad took over the former Canada Southern property on Grosse Ile, the Biddle House was again expanded and renamed the Island House. It was operated as a resort hotel for summer visitors to the island, many of whom arrived by train. Notable guests included Calvin Coolidge and Grace Coolidge and Orville Wright. The hotel was demolished in 1935. (Courtesy John Speer.)

The Island House, seen at the right, was well situated on the eastern shore of the island and offered its guests a pleasant view and easy access to the river. The stone gate at lower right marks the drive leading to St. James Episcopal Church (now St. James Chapel). The boathouse seen at left belonged to Dr. Burt Shurly, whose house can be seen just south of the Island House.

During its years of operation, the Island House offered many recreational activities for its guests, including boating, golf, tennis, card parties, and dancing. This c. 1910 view of the Island House's dock shows some of the boats available for use by hotel guests. Beyond is the railroad trestle and Stony Island. Houses for workers building the Livingstone Channel are just visible in the distance. About 1908, the casino was relocated from Island Boulevard to a spot just north of the present St. James Chapel. Tennis courts and a nine-hole golf course were laid out on land behind the casino, and the facilities were renamed the Country Club. This popular sports venue served both island residents and visitors for many years until the casino was moved to the corner of Meridian and Bellevue Roads to become the clubhouse for the new Grosse Ile Golf and Country Club.

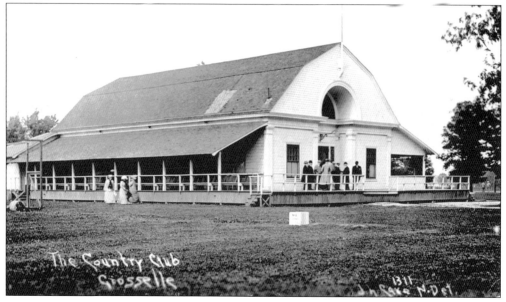

Grosse Ile became a popular vacation spot after the coming of the Canada Southern railroad. Many cottages were built for summer rental, including these on West River Road just north of Groh Road. Franklin A. Kelsey purchased the property in the 1870s, named it Holmcroft, and built a home for his family and five rental cottages along a semicircular drive off West River Road. Summer residents could enjoy cooling breezes off the river on the wide, tree-filled lawn fronting the cottages. Across the road, Kelsey built this two-story boathouse for the use of his guests. He provided transportation services from the depot in a horse-drawn omnibus. Holmcroft remained in operation until the mid-1930s, after which the cottages were gradually replaced by private homes.

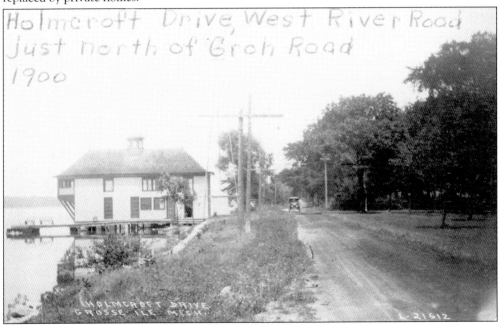

Four

THE DETROIT RIVER

The Detroit River is a 32-mile strait connecting Lake St. Clair with Lake Erie. The international boundary between the United States and Canada runs through it. Grosse Ile islands are situated in the lower river as it broadens and becomes shallow near the entrance to Lake Erie.

The first Great Lakes steamboat, named after the famous chieftain of the Wyandot Indians, *Walk-in-the-Water* chugged up the river in 1818. There were 37 steamers navigating the lakes by 1837, the majority having been built in Detroit. The hull of the *Uncle Sam* was built on Grosse Ile, then towed to Detroit and outfitted as a steamer.

In the late 1800s, Grosse Ile became a popular destination for recreational boaters and fishermen. Paddle steamers and trains brought passengers to resort hotels and summer cottages. Vacationers camped on Hickory, Sugar, and other off-shore islands where they enjoyed the natural setting and panoramic views of the river and Lake Erie. Along the shorelines of the main island, summer homes were built by wealthy residents from the Detroit area. The interior of the island was mostly undeveloped woodlands or had been cleared for farming. There were fisheries and cultivated orchards, their harvests delivered to Detroit markets.

By 1906, the river was the busiest commercial waterway in the world. Coal was carried to the northern lakes while grain and lumber were moved into Lake Erie and points east. The mining of copper and iron ore in the Lake Superior regions created need for larger steel-hulled carriers, deeper channels, and suitable navigational aids. The newly formed Lake Carriers Association wielded great influence on the national government to improve the rivers and harbors on the inland seas. Cutting down through 22 feet of river bedrock to form the Livingstone Channel was an extraordinary engineering feat.

Today reconstruction of rare coastal wetlands has provided compatible habitats for the return of wildlife. Conservation-minded island residents participate in organized programs to restore fragile marshlands and preserve the natural environment. The U.S. Fish and Wildlife Service manages Calf Island while Celeron and Stony Islands belong to the Michigan Department of Natural Resources.

Geologically the Thoroughfare Canal is a distributary of the glacial Detroit River flowing from northeast to southwest and dividing the ridges of the Grosse Ile moraine into two sections. Smaller channels flow between the islands at the southern tip. At one time, marshlands abounded in the shallow waters of these canals and along island shorelines. Today the preserved marshes and wetlands teem with waterfowl and numerous species of fish return to spawn.

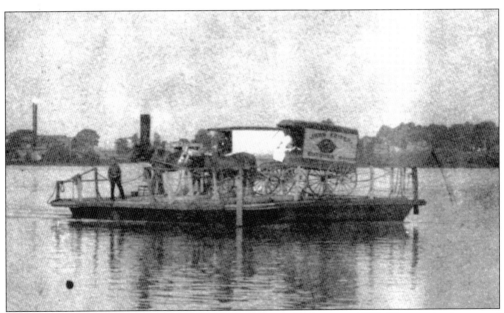

Horse-driven ferry service between Trenton and Grosse Ile began in 1851. The service later used this scow to transport passengers, animals, and vehicles across the Trenton Channel. It was powered by a motor launch (not pictured). Edward Voigt operated another passenger ferry across the north end of Trenton Channel until he opened the 1913 toll bridge (see page 92).

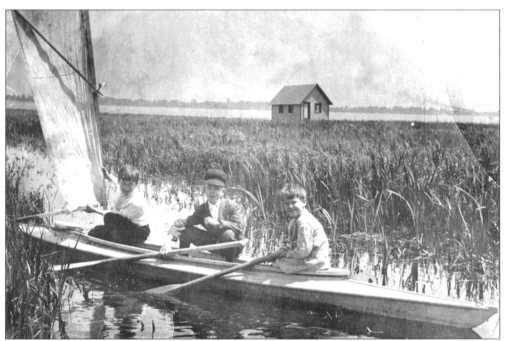

In this picture, taken about 1915 from East River Road near Island Boulevard, Norbert Burdeno (left), Philip Boucher (center), and Dayton Burdeno are paddling a boat along the reedy shore. The Frederick Burdeno boathouse in the background was the site of Grosse Ile's first yacht club. The marsh in this area has since washed away.

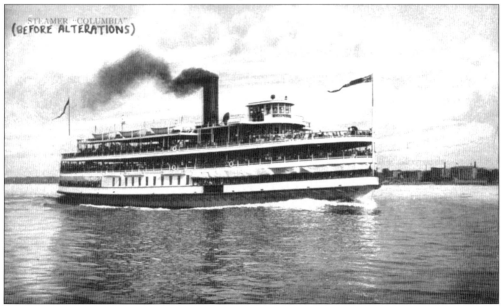

In the early 1800s, schooners dominated the commercial fleet because they could navigate shallow waters and carry freight in place of fuel needed to power steamships. From 1876 through 1890, the United States deepened and widened shipping channels for large cargo steamers. Passenger steamer *Columbia* made her maiden voyage from Detroit to Bob-lo Island on July 8, 1902. By 1904, more than seven million passengers a year were being carried on Detroit steamers.

Sturdy steel-hulled lake vessels with enclosed holds haul millions of tons of cargo to deep-water ports from Duluth, Minnesota, to the eastern end of Lake Ontario. Under the supervision of the U. S. Coast Guard, including the Lighthouse Service, the Steamboat Inspection Service, and the Bureau of Navigation, the waterways have become relatively safe for both commercial shipping and recreational boating.

By 1910, recreational boaters were numerous. The shallow water and sand beaches attracted weekend vacationers to island getaways. They traveled in the designated shipping lanes, often unaware of the danger of collisions with large freighters. The Lake Carriers Association requested that Congress enact laws to give the commercial vessels the right-of-way in narrow channels.

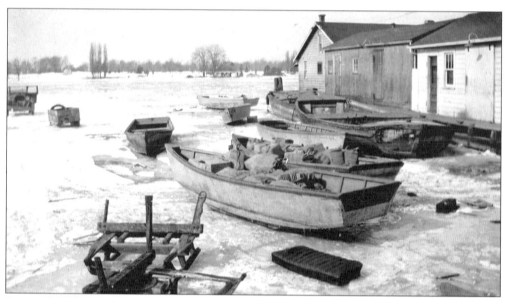

During Prohibition, liquor was brought from Canada by car, in boats, or dragged by submerged lines that could be easily cut if federal agents were in hot pursuit. When the river and lakes froze solid, liquor was transported across the ice in the lightweight automobiles of the 1920s. Alcoholic beverages were sometimes loaded into small boats and moved across the ice by skaters.

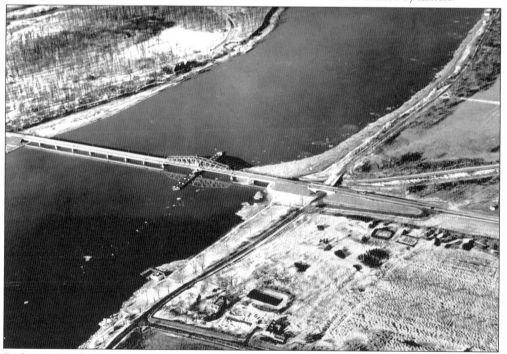

Built in 1931, this bridge for vehicular and pedestrian traffic spans the channel between Grosse Ile (right) and the city of Trenton, replacing the defunct Michigan Central Railroad bridge. The railroad tracks across the island were replaced by a roadway that is now known as Grosse Ile Parkway. Nearly three quarters of the traffic moving on and off Grosse Ile uses this bridge. (Courtesy Trenton Historical Society.)

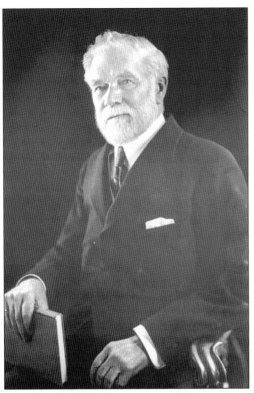

President of the Lake Carriers Association William Livingstone spearheaded the movement to develop commerce and safety for Great Lakes vessels. He organized the Michigan and Percheron Navigation Companies. In anticipation of the opening of rich grain fields and ore mines in the northwest, he was instrumental in construction of the Livingstone Channel in the Detroit River and additional locks at Sault Ste. Marie to accommodate new larger steel freighters. (Courtesy Library of Congress.)

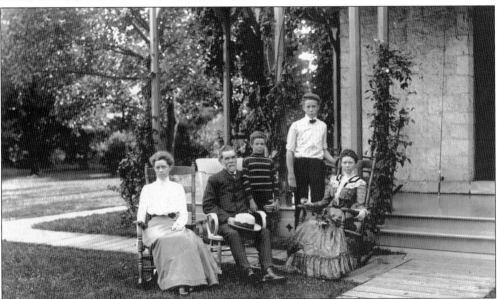

In 1865, Livingstone married Susan Ralston of Detroit. She was his closest confidant and companion during their nearly 60 years of marriage. They had eight children. William Allen and Robert Bruce were owners of Detroit Publishing Company. Another son, T. W. Palmer became president of the Dime Savings Bank. Pictured here are members of the Livingstone family in front of their "Rio Vista" home at East River Road and Grosse Ile Parkway. (Courtesy Library of Congress.)

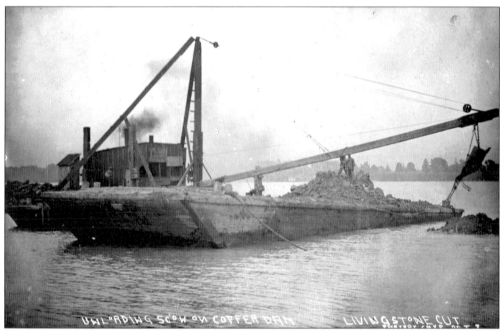

Work began on the Livingstone Channel in 1908. The channel was to be cut across the treacherous area known as the Lime Kiln Crossing between Stony Island and Bois Blanc Island, extending downstream to deep water in Lake Erie. Scows laden with earth and stone were unloaded by steam shovel to enclose a 6,000-foot stretch of riverbed, 300 feet wide.

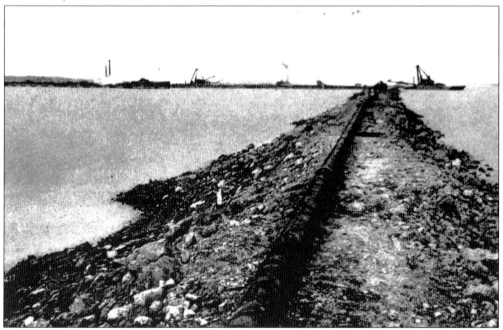

With the cofferdam in place, the largest ever built at the time, the water was drained from the enclosure, exposing glacial rock deposits and the limestone bedrock. Large rocks were loaded into baskets by steam shovels and carried off-site by means of conveyors. Upon completion, the ends of the cofferdam were removed but the sides were left in place for water flow compensation.

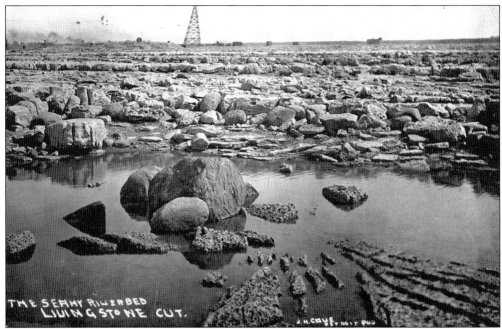

By 1907, Congress had appropriated $6.6 million for this project under the supervision of the U.S. Army Corps of Engineers. The channel had to be excavated to a depth of 22 feet below minimum water levels. Livingstone Channel was enclosed in a similar manner from 1932 to 1935 to widen it to 450 feet and deepen it to 24 feet. Subsequent dredging projects deepened the channel to 27 feet.

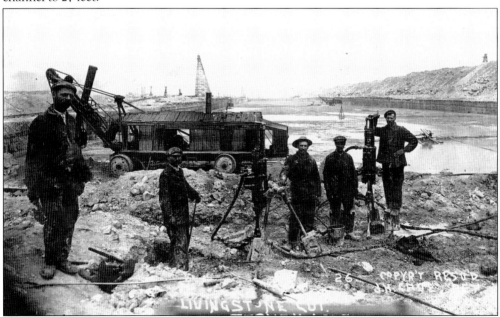

Powered by large steam-driven air compressors, pneumatic drills enabled workers to break apart the limestone riverbed for the steam shovels to load into the conveyor baskets or to plant charges for blasting. In the background are the towers supporting the conveyors that moved rock and debris out of the excavated area.

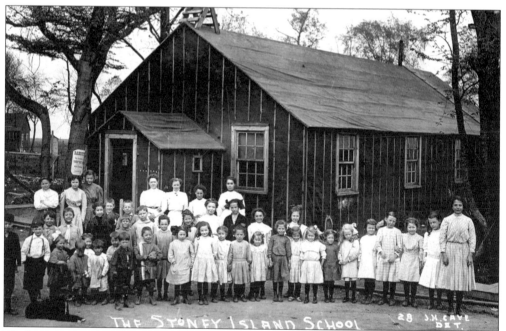

Workers employed on the Livingstone project lived with their families in temporary dwellings on Stony Island. The town included houses, a school, a church, and a store. They drew water from the Detroit River for drinking and bathing. It was a self-sufficient community, and a number of births were recorded here.

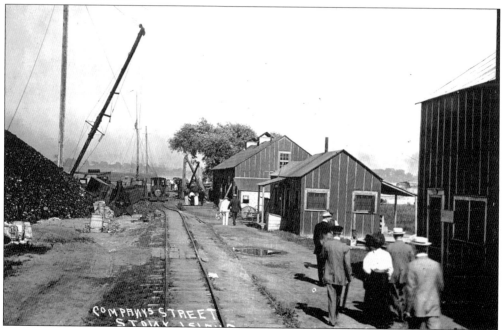

Headquarters for the work crews was located in Amherstburg, Ontario. Four companies were contracted to do the work on Livingstone Channel. The village on Stony Island was dismantled sometime after the completion of the channel in 1912. The Dunbar and Sullivan Dredging Company continued operations at Stony Island for many years.

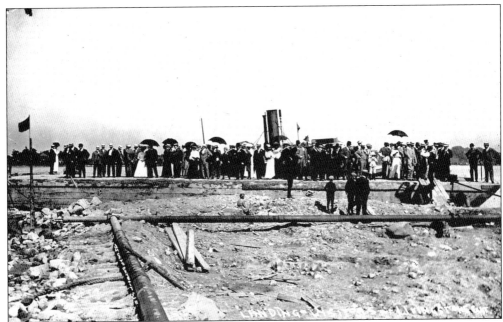

Passenger ships carried spectators to the work site for the opening of the new deep-water channel. Impressive ceremonies honored William Livingstone's foresight and accomplishments. In commemoration of his service to the shipping industry, the Lake Carriers Association commissioned Albert Kahn to design the marble William Livingstone Memorial Lighthouse that was erected on Belle Isle in Detroit.

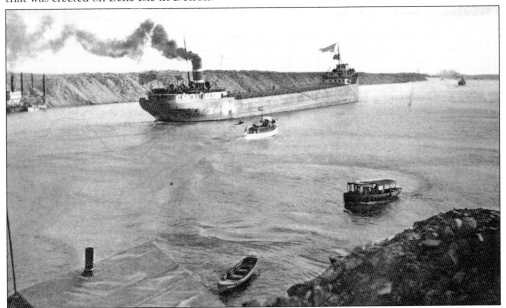

Opening day was October 19, 1912. The steamer *William Livingstone* was the first ship to pass through the Livingstone Channel. William Livingstone piloted the ship that bore his name through this new deep-water passage, the culmination of years of planning finally realized. In 1916, the Lighthouse Service installed two semaphore signals to aid vessel masters in maintaining the required five-minute interval between ships navigating in the channel.

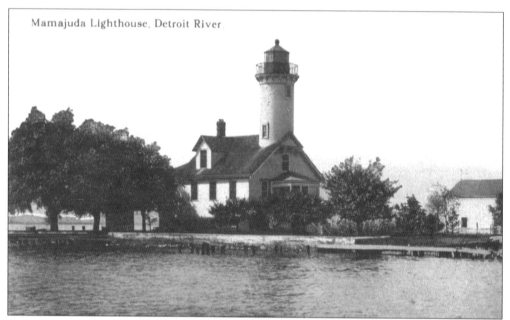

Mamajuda Lighthouse, Detroit River

Early ship captains navigated the river only by daylight, dropping anchor at night. In the mid-1800s, lighthouse beacons began guiding river traffic. Mama Juda lighthouse was built probably in the 1860s to warn ships away from this large shoal. The keeper lived at the lighthouse, keeping the lamp fueled and maintaining the buildings. The lighthouse was replaced by a black skeleton tower in 1916.

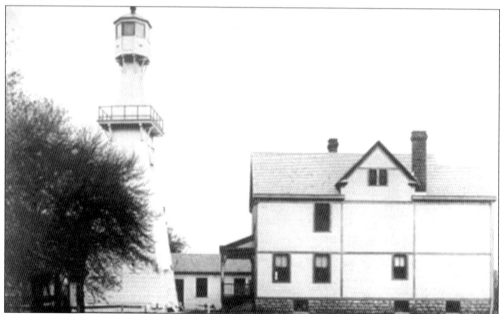

The Cleveland Vessel Owners Association petitioned Congress to fund and construct a series of channel range lights on the northern end of Grosse Ile to assist ships in avoiding shallow areas in the river and along island shorelines. The north channel rear range light was established in 1894, marking the Fighting Island channel. In the early 1900s, this light was turned off because the channel was changed. The home pictured here still stands on Parke Lane.

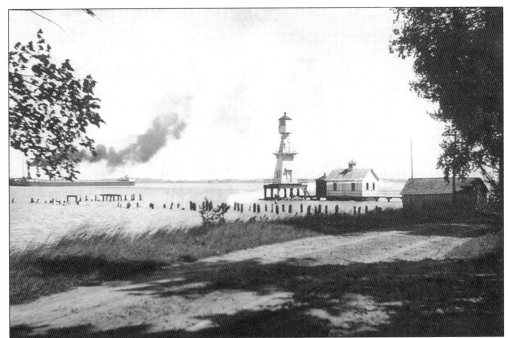

At Lighthouse Pointe, the original north channel front range light was established in 1894 to serve downbound river traffic. An oil house and boathouse were situated next to the lighthouse. A small keeper's house is shadowed in the foreground. The pilings are the remainder of the Alexander House hotel dock. Note the length of the passing cargo steamer in 1904.

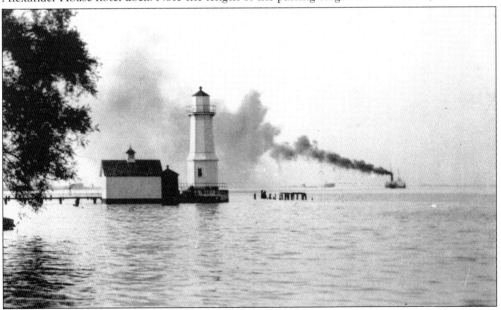

The northernmost of the north channel range lights is the only lighthouse remaining on Grosse Ile. It was rebuilt in 1906 as the classic white structure shown here. The interior is paneled with varnished Michigan pine, and a wooden circular staircase climbs to the light stanchion. With an occulting white beacon, it remained in service until 1963. It is maintained by the Grosse Ile Historical Society.

Established in 1891 on Hennepin Point, the Grosse Ile south channel front (below) and rear range lights marked the channel for upbound river traffic from the Lime Kiln Crossing to a point south of Mama Juda Island. The keeper lived on Mama Juda and rowed more than a mile every day to Hennepin Point to fuel the kerosene lanterns, swab glycerin on the windows to keep them from frosting over, and refill the cisterns with river water. He kept the buildings clean and painted. In 1929, the lights were electrified, and in 1932, the last keeper left Grosse Ile as the Coast Guard took charge. After the shipping channels were dredged and straightened, these lights went out of service. In the late 1940s, the lights were turned off permanently and the Fresnel lenses were removed by the Coast Guard.

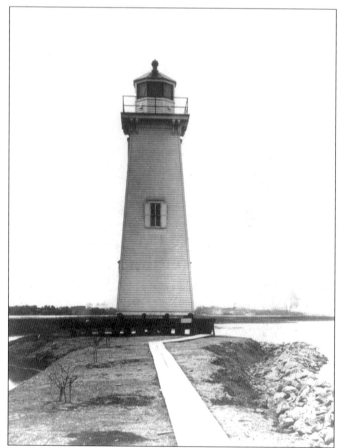

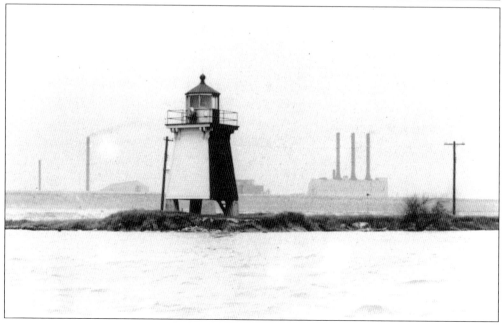

The son of Joshua Waterman of Grosse Pointe, Cameron Davenport Waterman was graduated from Yale University in 1874. In the late 1870s, he purchased 220 acres of farmland on Grosse Ile. He also sold real estate and owned a plantation in Cuba. The family lived in the "Lilacs," the former Smyth-David home, during the summer months and resided in Detroit during the winter. The house burned down in 1917.

Waterman relaxes on the verandah at the Lilacs, lush with plants and the wooded island surroundings. He financed the first telephone cable to Grosse Ile. Waterman and his wife, Elizabeth (Beach), were nature lovers. He hired farmers to till the land and kept a dairy herd. Elizabeth loved flower gardens and entertaining dinner guests. They had two sons, Cameron Beach and Ira.

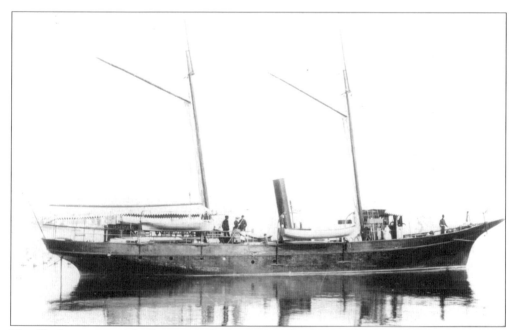

The *Uarda* was a coal-fired steam yacht. It was 100 feet long and was used by the Waterman family for cruising on the Great Lakes. As the elder Cameron sailed across Lake St. Clair, he whistled in salute whenever he passed his family home. The Watermans took extended cruises mainly along the northern shores of Lake Superior. The ship was sold in 1900.

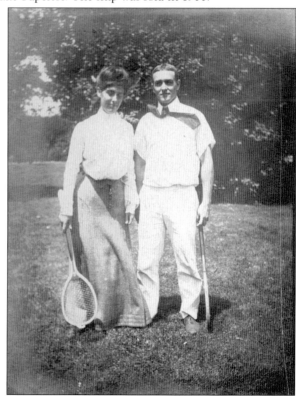

Cameron Beach Waterman was born in Detroit in 1878. He was a graduate of Yale University in 1901 and Yale Law School in 1903. In the summer of 1904, he and his fiancée, Lois Fleming Miller of Pittsburgh, spent a relaxing summer together at the Lilacs canoeing in the cattail marshes, sailing, playing tennis, and enjoying island life.

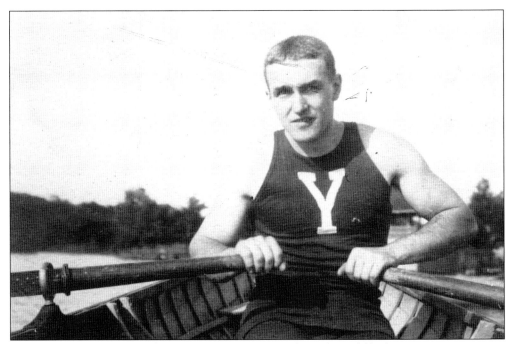

Cameron, captain of the Yale University rowing crew, knew how difficult it was to row against a strong river current. While in law school, he overhauled and cleaned a four-cycle air-cooled motorcycle engine. Hanging it over a desk chair to work on it, he realized he might be able to fasten it to a rowboat transom and attach a propeller to drive the boat, using the engine as a rudder.

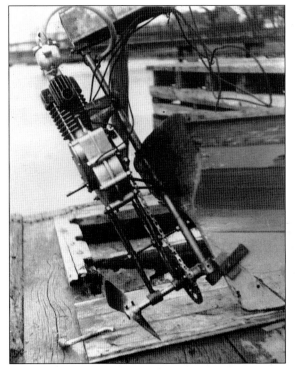

The first outboard motor was built in a Detroit machine shop from Waterman's drawings. In February 1905, from Grosse Ile, he and some friends started across the channel but ice chunks forced the chain off the sprocket. They rowed back, repositioned the chain and made a successful crossing. Waterman established the Waterman Marine Motor Company and built 25 Waterman Portos in 1906. They eventually manufactured and sold 1,000 outboard motors yearly.

Five

HICKORY AND SUGAR ISLANDS

Hickory and Sugar Islands at the southeast end of Grosse Ile provide spectacular views of the Detroit River and Lake Erie. They were regular picnicking and camping spots for Detroiters and local residents as early as the 1870s. These islands, as well as several others, were owned by John P. Clark, shipbuilder and owner of vessels including the *Pearl* and *Riverside*, which made regular stops at Grosse Ile. He also operated fisheries on Mama Juda, Hickory, and Sugar Islands.

Clark died in 1888, and about this time his heirs started developing an amusement park on Sugar Island. They built docks, a dance hall, and a refreshment stand and began offering daily excursions to the island to groups from Toledo and Detroit. By 1909, the island had been sold to the White Star Line and additional facilities were built to attract more visitors.

Meanwhile, Lower Hickory, which had been used for many years as a temporary campground by Grosse Ile residents, began to attract family groups, primarily from Detroit, who came to spend the summer. They were able to rent their favorite camping spots from the Clark estate and brought tents and provisions down from the city to a dock on Upper Hickory. From here they had to carry all their belongings down and across the channel to their chosen spot on Lower Hickory. The farmer and island caretaker Joseph Clark lived and operated a farm on Upper Hickory. He provided the campers with fresh vegetables and fruits as well as ice, which he had harvested from the river during the winter and stored in an icehouse. Other food had to be brought from home or purchased by campers after rowing or sailing to Trenton or Amherstberg.

Leaving their families to enjoy the pleasures of Hickory Island, the men made the long trip back to the city each week by boat or train—sometimes rowing all the way to Detroit—and returned to the island each weekend.

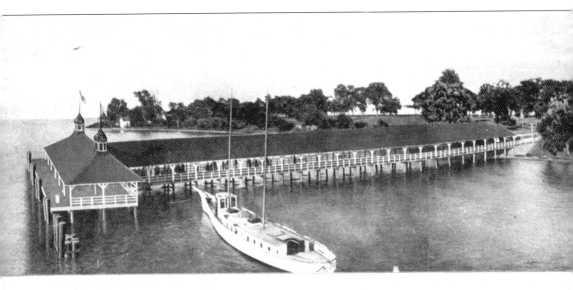

This 1909 postcard view of Sugar Island shows the extensive facilities that had been built at the park by that date. The approximately 40 acres of the island were completely given over for the use of visitors. They arrived by scheduled steamers from Toledo and Detroit as well as by smaller boats from Grosse Ile and other downriver communities. The amusement park offered two docks for excursion ships and dockage for private watercraft, a bathing beach, a dance pavilion (its

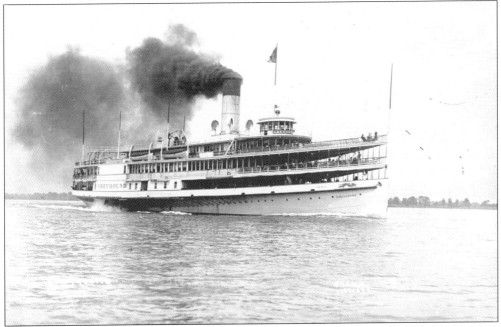

The *Greyhound*, based in Toledo, and the *Tashmoo*, based in Detroit, were the White Star Line's principal boats that brought groups on outings to Sugar Island. Both were side-paddle wheelers. The *Tashmoo*, pictured here, traveled between Detroit and Port Huron, stopping at several ports including Sugar Island and the White Star Line's Tashmoo Park on Harsen's Island.

66

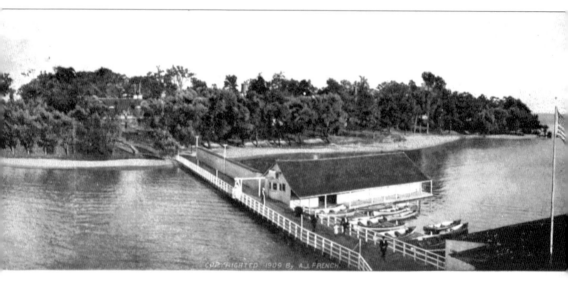

roof can be seen just right of center), a children's playground with a merry-go-round, and shaded picnic grounds. The small boats at lower right probably belong to the park's boat livery, which offered city dwellers the opportunity to pilot their own craft and take advantage of the good fishing in the surrounding river. (Courtesy Sheila Beaubien.)

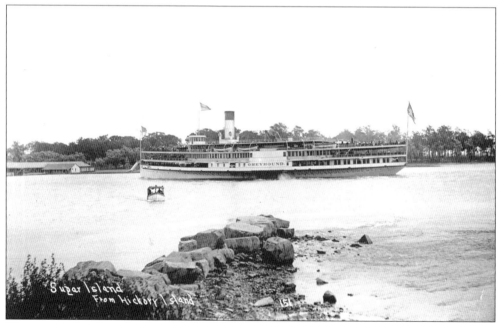

The steamer *Greyhound* is shown here arriving at Sugar Island with a load of visitors for a day's outing at the park. Smaller boats such as the *Wyandotte* brought visitors from the Hickory Island dock and from other downriver locations. A rock pile on Hickory Island in the foreground marks the entrance to the channel dividing Upper and Lower Hickory; it is the site of the present Grosse Ile Yacht Club's dock.

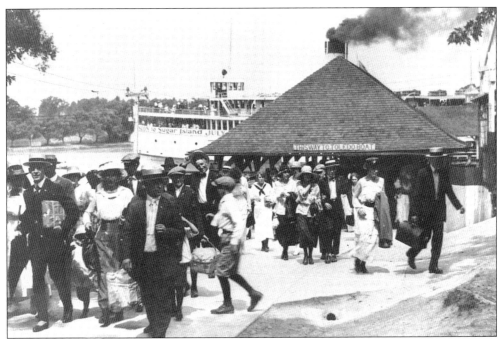

Based on the banner draped over the rail, this boatload of visitors arriving at Sugar Island has likely come on an organized outing. The boat is neither the *Greyhound* nor the *Tashmoo*, but one of the line's smaller boats, possibly the *Wauketa*. Some individuals are carrying parcels and picnic hampers, anticipating having lunch at the picnic grounds. A covered boat dock protected guests from inclement weather. (Courtesy Joan Strickler.)

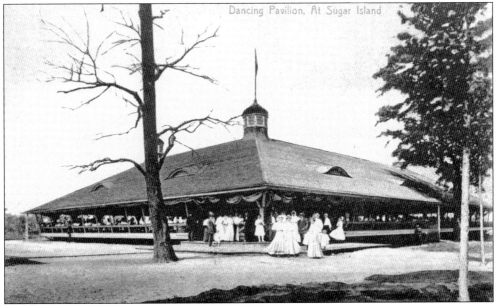

The dance pavilion on Sugar Island was one of the park's biggest attractions. White Star Line literature boasted of its steel arch construction with no posts and 14,000 square feet of clear hardwood dancing surface. Dancing was free. The orchestra is said to have played on a raised platform in the middle of the floor—so high that the dancers could glide under it.

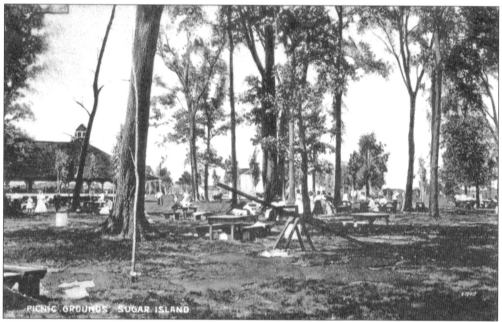

PICNIC GROUNDS SUGAR ISLAND

A picnic ground with convenient tables bordered the dance pavilion. People who did not bring their own picnic lunches could buy sandwiches and beverages at the refreshment stand operated by the park. Since no liquor was allowed in the park, a day's excursion to Sugar Island was an attractive destination for families and church groups.

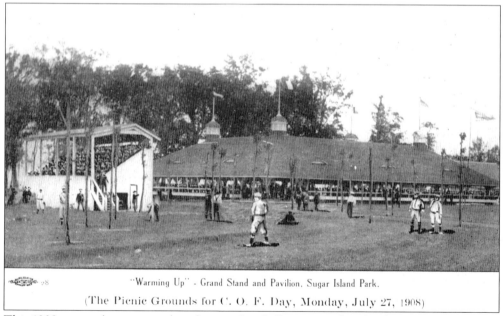

"Warming Up" - Grand Stand and Pavilion, Sugar Island Park.
(The Picnic Grounds for C. O. F. Day, Monday, July 27, 1908)

This 1908 postcard view was taken during a baseball game on the island's athletic field with a crowd of spectators looking on from the grandstand. Teams from Hickory Island regularly played games here, and it is reported that players would often cool off after the game by swimming back to Hickory.

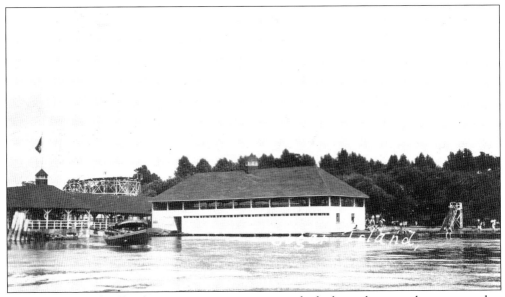

The bathing beach offered visitors an opportunity to refresh themselves on a hot summer day. The building at center is probably the bathhouse and possibly the office for the boat livery. The slide at right must have been popular with youngsters at the beach, and the roller coaster, seen just above the dock at left, was surely popular with all ages.

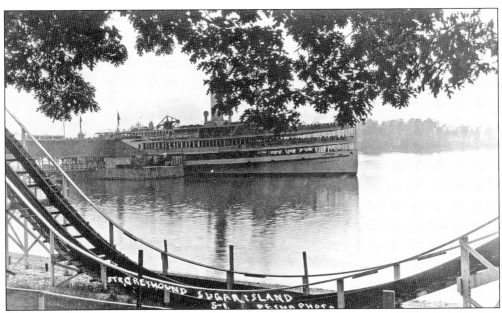

In the early 20th century, Louis James Pesha owned a postcard company in Marine City. He specialized in taking pictures of commercial ships in the St. Clair River and elsewhere on the Great Lakes. His views are much sought after today by collectors. This striking view of the *Greyhound* docked at Sugar Island is an example of his work.

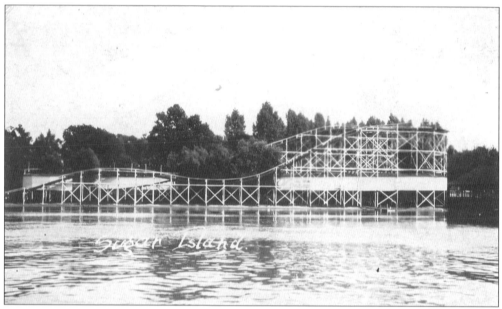

Sugar Island's heyday lasted from the first decade of the 1900s into the 1930s. By that time, interest began to wane since more and more families owned private cars and had other vacation options. The roller coaster was a late addition to the park; not appearing in early postcard views, it was probably built around 1920. The Sugar Island Park closed soon after the *Tashmoo* ran aground and sank in 1936.

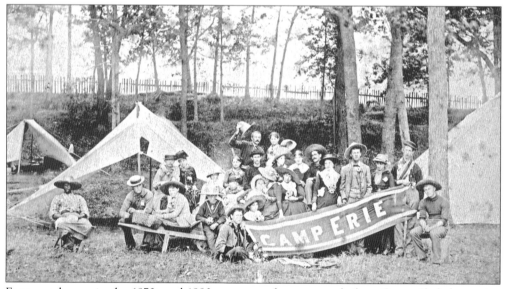

For several years in the 1870s and 1880s, a group of young people from Grosse Ile led camping parties to Lower Hickory. The camp, called Camp Erie, was set up close to the water on the eastern shore. For their cook, they brought along Joey Lockman (seated at left), who had served Col. Thornton Fleming Brodhead during the Civil War and later came to Grosse Ile to serve in the Brodhead household.

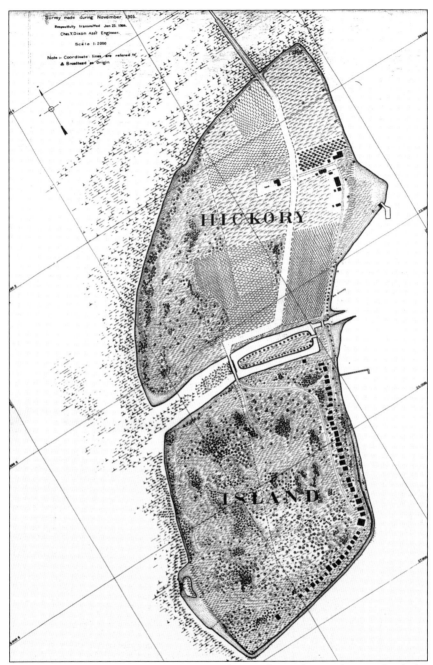

This Corps of Engineers topographical map dated 1905 shows that Hickory is divided into two large islands. At this time Upper Hickory was principally farmland. The only buildings were the caretaker's house and barn and a few outbuildings. Conversely, the eastern shoreline of Lower Hickory was well lined with cottages. Cottagers arrived at the dock on Upper Hickory and used a path along the riverbank to reach the footbridge leading to Lower Hickory. The bridge crossed the channel near Peek-A-Boo, the small island between Hickory's upper and lower sections. This is the earliest map known to show a road leading to Lower Hickory with a bridge for vehicles to cross the channel. (Courtesy Donald Hartwell.)

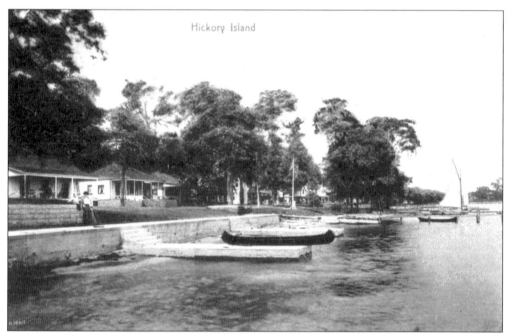

Hickory Island

During the 1890s, it became possible for the Detroit families who had been camping on Lower Hickory to lease their favorite camping spot to build a cottage. Building materials had to be transported to the island by scow and hand carried to the building site. The cottages, built close together on narrow lots, had wide front porches to allow cottagers to enjoy the summer breezes and views of Lake Erie.

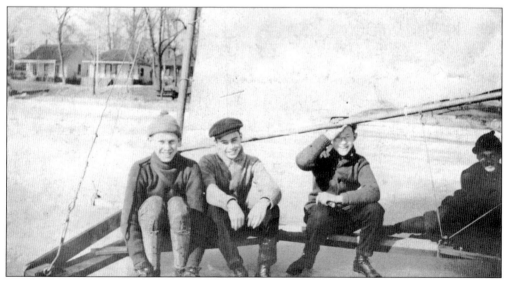

Iceboating has long been a winter sport enjoyed by Grosse Ile residents. Those living on Hickory Island are especially fortunate in that they have all of Lake Erie at their front door. These Hickory boys, (from left to right) Herb Shaw, Ed Howarn, unidentified, and Ted Barbier, pose with their homemade iceboat off the eastern shore of Hickory about 1920. (Courtesy Shaw family.)

In 1904, after the settling of the Clark estate, residents of Lower Hickory formed the Hickory Island Company and purchased the eastern three-fifths of the island. The picket fence shown here marks the northern boundary of the Hickory Island Company's land. The area beyond the fence, but still on Lower Hickory, is the site of the present Grosse Ile Yacht Club. (Courtesy Robert George.)

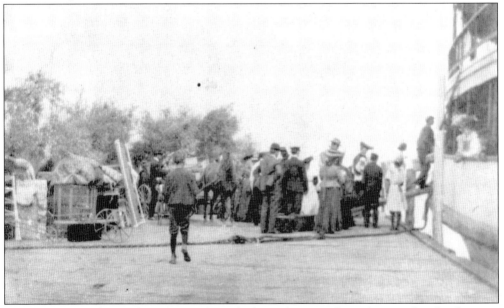

In this snapshot taken at the Upper Hickory dock, residents are shown leaving the island on one of the steamships that stopped at the island. They may be returning to Detroit after spending the summer on Hickory since the buggy in the center of the picture and the flatbed cart at left seem to be loaded with household supplies. (Courtesy Robert George.)

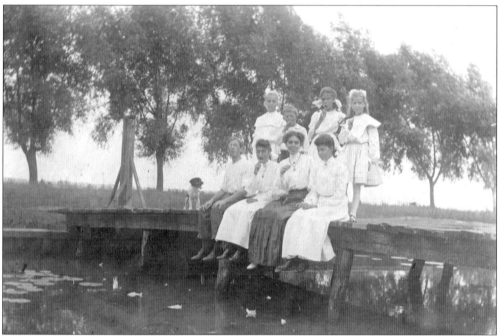

Around 1905, this family group posed for a picture on the footbridge leading from the dock on Upper Hickory to Lower Hickory. The Detroit River is behind them. Wheelbarrows and small carts could use this bridge, but larger vehicles were unable to reach Lower Hickory until the sturdier bridge was built across the channel farther west. (Courtesy Robert George.)

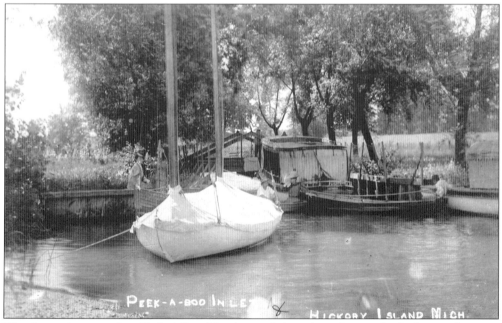

The channel surrounding Peek-A-Boo Island provided a safe anchorage for docking and storing boats. In this view taken about 1910, several boats are shown docked near a small bridge, probably one linking Upper Hickory with Peek-A-Boo Island. The boxy craft nearest the bridge looks like an early version of a houseboat.

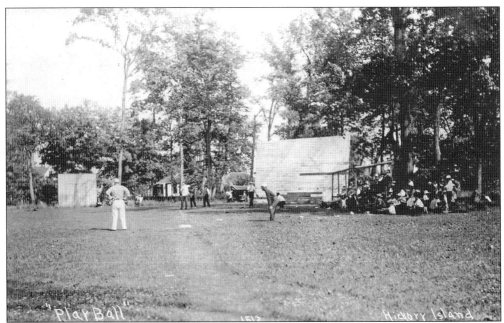

By 1909, the Hickory Island Park "infield" area behind the cottages was sufficiently cleared to permit its use for baseball games. A grandstand was erected northeast of the present Hickory Island Pavilion. The residents formed two teams, the "Uppers" and "Lowers," each team member's affiliation depending on where he lived on Lower Hickory. Pennants won in these contests still hang in the pavilion. (Courtesy Shaw family.)

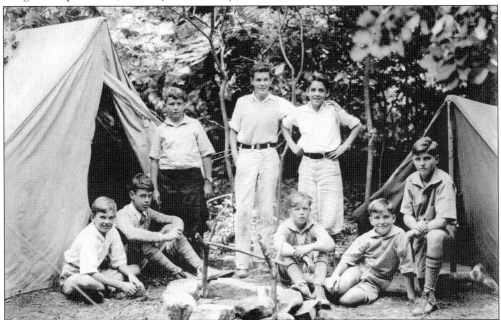

Camping remained popular on Hickory Island into the 1930s. These boys are enjoying a camping experience among the dense undergrowth on Peek-A-Boo Island. They are, from left to right, (first row) Ralph Wilson, Junior Humphries, Bob Schmidt, Don Hartwell, and Bob Hartwell; (second row) Jack Debo, Dick Debo, and Dean Conway. (Courtesy Donald Hartwell.)

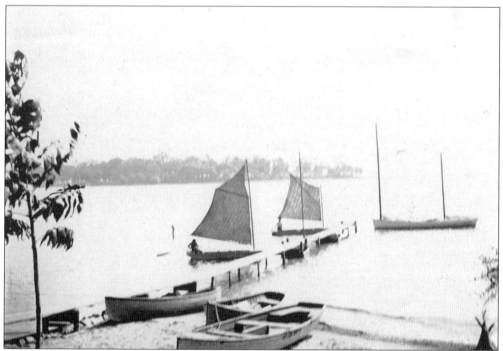

Sailing has always been a popular sport on Hickory Island. On sunny, windy days residents enjoy watching sailors as they maneuver their boats in the water. In about 1915, these young sailors are shown getting their small gaff-rigged boats ready for a sail. Tied up at the end of the dock is a yawl. The southern tip of Sugar Island can be seen in the distance. (Courtesy Robert George.)

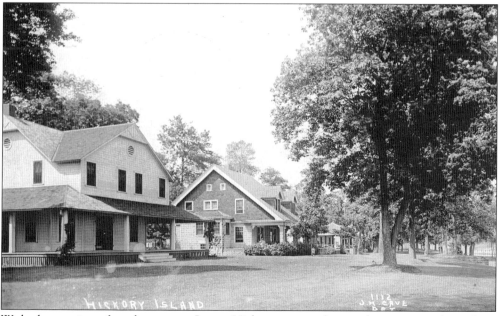

With the coming of road access to Lower Hickory, more substantial cottages, such as those shown here, were built. Over time, the former cottages on Hickory have been rebuilt or replaced so that today all homes are inhabited year-round.

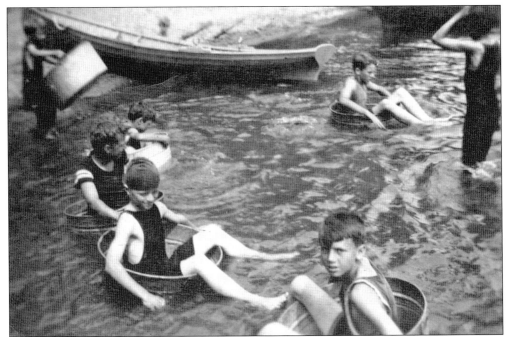

Hickory Day is eagerly anticipated by all Lower Hickory residents. It has been celebrated on the second Saturday in August since 1893. For years the day began with a children's parade and ended with fireworks. In between there were races of all kinds, both on land and in the water. These boys have borrowed their mothers' washtubs and are ready to compete in the washtub race. (Courtesy Shaw family.)

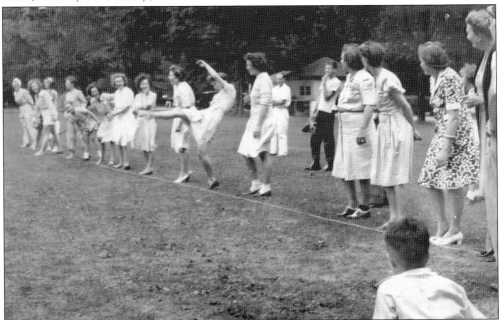

Other events on Hickory Day included ball games, scull rowing races, sailboat races, and dances. One event for the ladies was the "Ladies' Slipper Kick." In 1946, Mildred Hartwell is shown kicking like a Rockette to see how far she can throw her shoe. (Courtesy Donald Hartwell.)

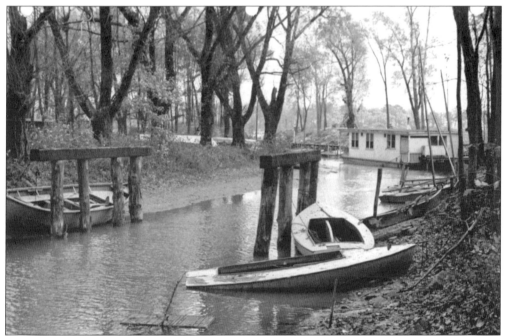

The Grosse Ile Yacht Club was organized in 1934 using Frederick Burdeno's boathouse off East River Road as their first clubhouse. Because of growing membership, they purchased a houseboat and a strip of land on Hickory Island including Peek-A-Boo Island. Here the houseboat is anchored on the Lower Hickory side of the Peek-A-Boo channel. The bridge supports in the foreground anchored an early bridge from Lower Hickory to Peek-A-Boo.

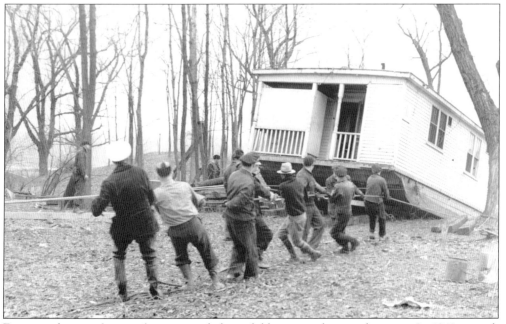

For several years the members enjoyed their clubhouse at the new location. In 1943, a work party was organized, trees were cleared from Peek-A-Boo, and the members pulled the houseboat ashore using ropes, wedges, a block and tackle—and lots of muscle.

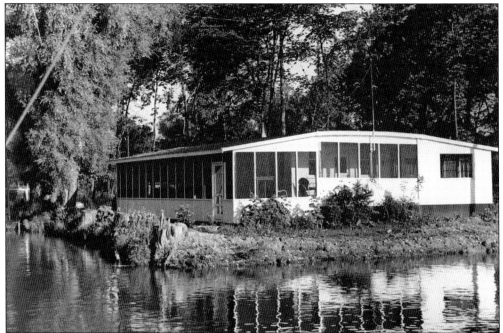

Using specialty skills of the members and donated time, a foundation was built for the houseboat. Porches with windows were added, the clubhouse renovated, and finally the members had a clubhouse on dry land. The canal was dredged so members' boats had a protected place to anchor. Dayton Burdeno was elected first commodore of the Grosse Ile Yacht Club.

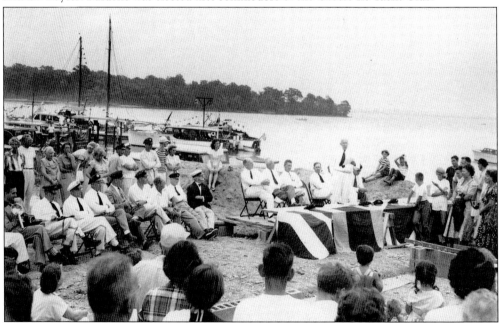

In the 1940s, a new clubhouse was proposed by club members. It would be located on the raised point of land opposite Peek-A-Boo and would offer members a good view of Lake Erie and the sailboat races. After delays necessitated by World War II, the laying of the cornerstone in 1949 was reason for a great celebration, which took place in front of the proposed new clubhouse.

Six

Around the Island

Grosse Ile homes are as distinctive and as varied as the people who built them. From the historic homes on East River Road to the elaborate boathouse of Harry Bennett and the elegant mansion of Ransom E. Olds, all are testimonies to their owners and their tastes.

Although farming was the primary business of early Grosse Ile residents, other occupations also existed. Limestone was quarried from Stony Island before 1749 for the building of Fort Ponchartrain (Detroit) and continued through the mid-1800s. Several lime kilns were in operation obtaining stone from this quarry as well as one on the south end of the island. Fisheries were in operation from the early 1800s when whitefish and freshwater herring were abundant. Ferry service became a business, as did liveries. The railroad brought hotels and boardinghouses. As the population grew, grocery stores were added, and in the 1930s, Richardson's gas station opened.

Life on Grosse Ile naturally centered around the water. Nearly every resident had a boathouse because a boat was often necessary for transportation to the mainland as well as for hunting and fishing excursions. Before installation of a water main and supply line from the mainland, Grosse Ile residents depended on windmills to pump water from the Detroit River for all purposes except drinking.

Early roads were laid along the river and from east to west with bridges over the Thoroughfare Canal. Roads were often a problem, with the Grosse Ile clay forming deep ruts in the spring and fall and clouds of dust in the summer.

But whatever hardships living on Grosse Ile brought, life around this beautiful island was enjoyable, exciting, and desired by many.

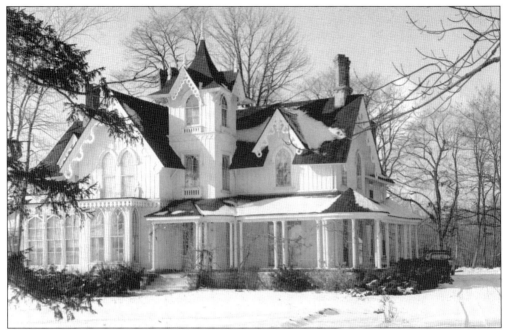

The Samuel Lewis home, called the perfect house, has never been remodeled since it was built in 1859. It is of Gothic Revival style and built of brick with a wood veneer exterior. Once called "the Lilacs" because of the beautiful lilac hedge planted there, it is now known as "the Wedding Cake House." It is located on East River Road.

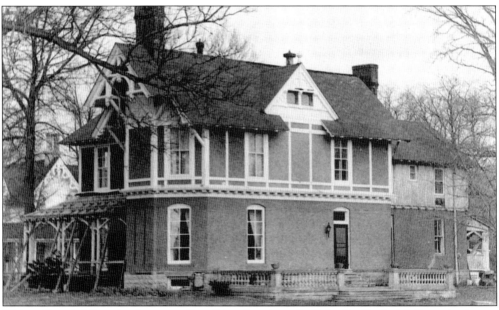

This stick-style Victorian home on East River Road was built by Dr. Frederick Pope Anderson in 1881. The house has unique features such as a secret passageway and a hidden bedroom. Dr. Anderson was a roommate of Abraham Lincoln's son Robert while attending Harvard. His wife, Mary Campbell Douglass, was the daughter of Judge Samuel T. Douglass and one of the first women to attend the University of Michigan.

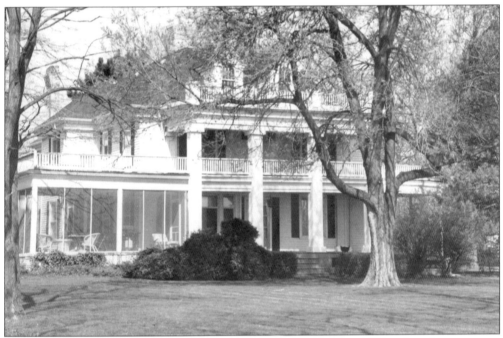

This Georgian Colonial–style home on East River Road was built in 1906 and used as a summer home by the family of the prominent Detroit physician Dr. Burt Shurly. Shurly also served for many years on the Detroit Board of Education.

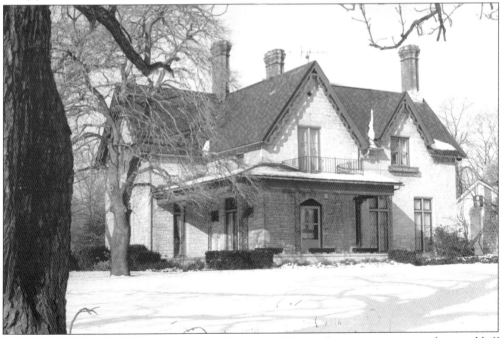

The Dudgeon home, built of limestone from the Grosse Ile quarry, is situated on a bluff overlooking Grosse Ile Parkway and East River Road. It was built in 1860 and designed by architect Gordon Lloyd for Anthony Dudgeon. William Livingstone, for whom the Livingstone Channel is named, also lived here. At that time the home was called "Rio Vista."

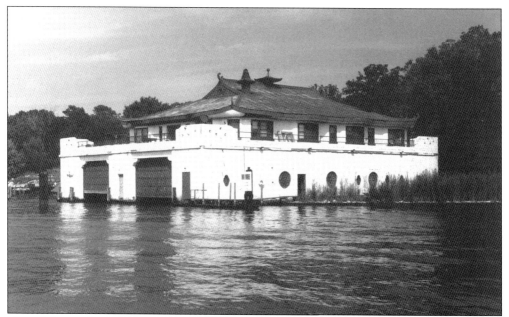

This elaborate boathouse of oriental-type architecture was built in 1939 by Harry Bennett, personnel director for the Ford Motor Company. It was built with steel pilings in the Trenton Channel. It features an underground tunnel with three entrances in the house, two of them concealed, and a secret room with hidden passageways. Known locally as the "Pagoda House," it is located on West River Road.

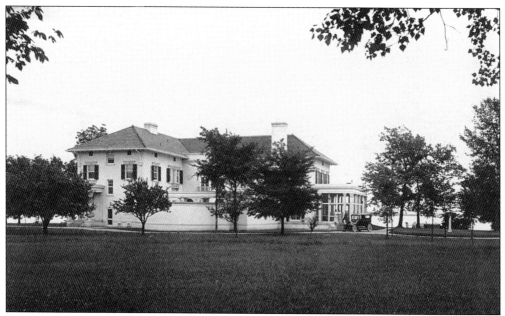

Auto pioneer Ransom E. Olds built this estate in 1916 on the east side of Elba Island. It was designed by Albert Kahn and used as a summer home. At the time it was the largest home on Grosse Ile: three stories with 30 rooms, a ballroom, and magnificent grounds. During World War II, the mansion was used by the USO. Today it is divided into apartments, still keeping its old elegance.

Horace Gray, when he returned from the Civil War, started a small grocery store on the river in front of his home on East River Road. He ran it only halfheartedly and sold it in the 1890s to Arthur Graves, who managed the store and rented the upper room for dances and parties. He eventually moved his business to Macomb Street. Graves, Grosse Ile's postmaster for 12 years, also used his Macomb Street building as a post office and a library. Pictured above is the Graves store on the waterfront. The bottom picture is the store on Macomb Street in 1921.

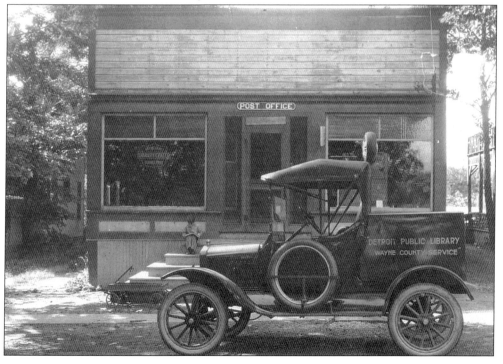

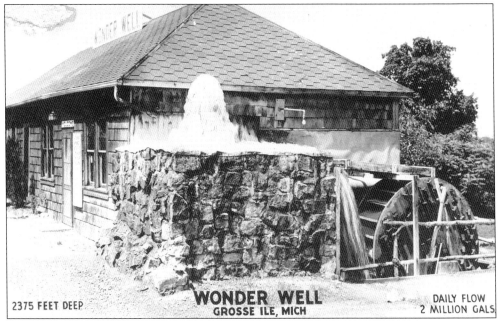

2375 FEET DEEP

WONDER WELL
GROSSE ILE, MICH

DAILY FLOW
2 MILLION GALS

The Wonder Well produced a natural flow of two million gallons of water daily. The well was drilled in 1903 by a gas company looking for oil but striking mineral water instead. It was bottled and sold for medicinal purposes throughout Michigan and Ohio until 1957. The well ran dry in 1994.

Boat liveries have given long years of service to Grosse Ile. Charles Gronda, who ran a ferry from Grosse Ile to Stony Island, operated a livery on the east end of Grosse Ile Parkway. Smith's Boat Livery was located in a cut near Elba Island. Pictured here is Hoover's Livery that is near Upper Hickory Island at the outlet of Frenchman's Bay. (Courtesy Carolyn Hoover Rubin.)

Patrick Coleman opened his wooden grocery store on Macomb Street in 1895. His son took orders by riding his bike around the island. Orders were then delivered by horse and buggy. Matt Mickleburough, who clerked for Coleman, bought the business and erected the brick building shown here. Maurice Mickleburough is on the far right.

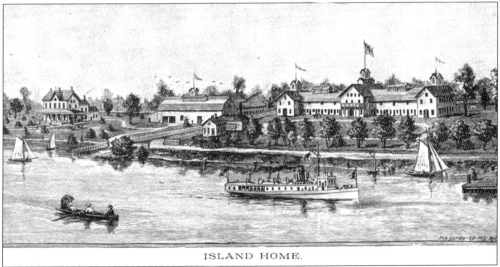

ISLAND HOME.

One of the most ambitious businesses on Grosse Ile was the Island Home Stock Farm established around 1880. Its huge barns and pastures covered most of the north end of the island. The farm bred and raised Percheron, Clydesdale, and French coach horses.

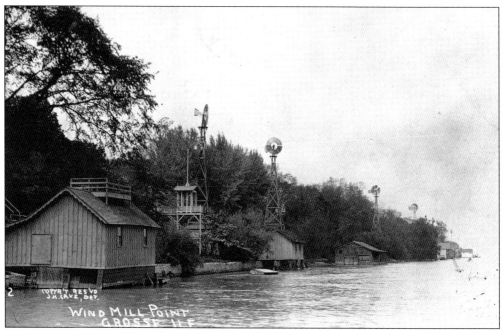

Taken from the water about 1910, this image shows the shore off East River Road just north of the present Grosse Ile Parkway. It shows boathouses and a line of windmills dotting the shoreline.

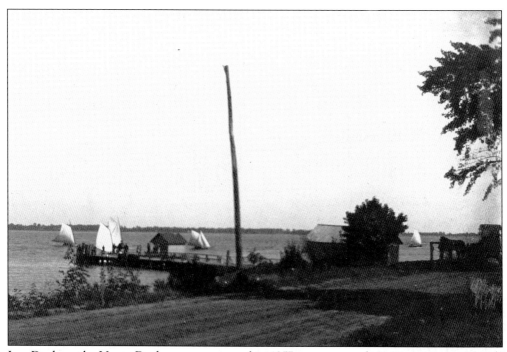

Ives Dock, or the Upper Dock, was constructed in 1857 to accommodate river steamers. Vessels could use this dock as soon as the ice cleared in the spring or in periods of low water. Steamboats traveling between Detroit and points south scheduled regular stops at Ives Dock. Pictured here at the Ives Dock are sailboats around 1900.

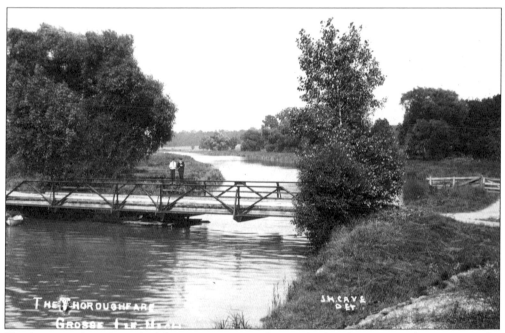

Two boys stand on the rail of the West River Road swing bridge about 1910. The view is to the northeast, and the railroad tracks across Grosse Ile are just out of view at the right of the picture. Unlike today, West River Road must have crossed the tracks here at grade level.

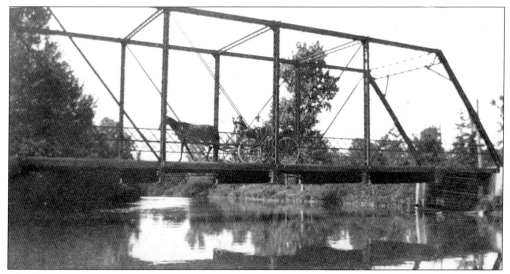

This bridge on Ferry Road (formerly called Lime Kiln Road) was erected over the Thoroughfare Canal in 1854 when the road was graded and improved. Lime Kiln Road was renamed when ferry service to Trenton began at its foot in 1851. This photograph was taken in the early 1900s.

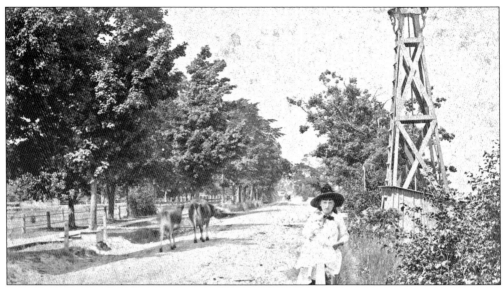

One of the first roads laid out on Grosse Ile was East River Road. The site was surveyed in 1823, and the road was constructed soon afterward. The young lady above with her baby is shown resting on a rail some time in the 1870s. East River Road originally ran farther north than it does today. The scene below shows East River Road in 1900 north of Horsemill Road near the Ives home and dock. In 1914, residents of this area petitioned Monguagon Township to have their section closed because of the "nuisance of people coming to the island for picnics". After much arguing and protesting, that portion was closed and a new road, Parke Lane, was built 1,000 feet to the west.

This pastoral scene shows Horsemill Road looking east over the Thoroughfare Canal around 1900. This road is named after the horse-powered mill built by William Macomb for the use of local farmers. The mill began operation in 1787. Horsemill Road was surveyed and laid out in 1822 and was the first road to connect the east and west sides of Grosse Ile.

The southern end of East River Road was once called Lover's Lane. It was an overgrown and grassy road arched with trees and framed by wild shrubs. Narrow marshes separated Hickory and Elba Islands from this section. The road led to the old limestone quarry that was a favorite place for picnics.

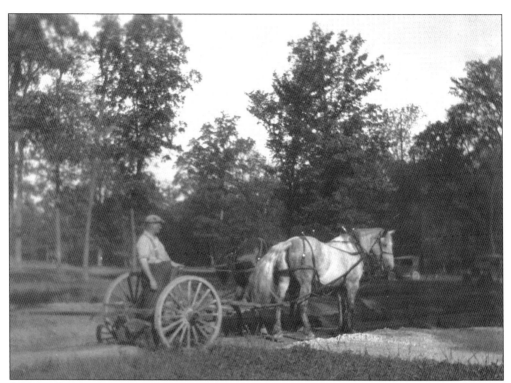

Since its formation in 1915, the Grosse Ile Township Road Commission was concerned with the platting of future roads and the improvement of existing roads. This horse and scraper were part of an extensive improvement project in the late 1920s.

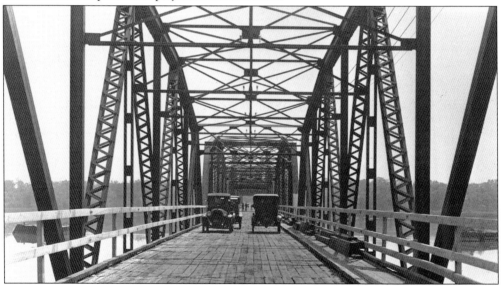

The toll bridge, built in 1913 to connect Grosse Ile to the city of Riverview, enabled automobile and horse-drawn traffic to easily and quickly cross the Trenton Channel of the Detroit River for the first time. After automobile traffic crossing the toll bridge became the most popular means of traveling to and from the island, the Michigan Central Railroad ceased daily passenger service. (Courtesy Trenton Historical Society.)

Seven

Churches and Schools

Churches have played a significant role in the development of Grosse Ile. In 1793, the Quakers conducted a service when they came to Grosse Ile to participate in a Native American council, but they did not settle here.

In 1805, the hub of Roman Catholic activity was centered at the mansion house owned by the Macomb (Brodhead) family. A priest from Assumption Parish in Canada came to celebrate mass. In 1869, Mrs. Thornton Fleming Brodhead (Archange Macomb) and Mrs. John Wendell (Catherine Macomb) arranged for the purchase of an abandoned school building to use as a church. The building was moved to the site of the present-day rectory on East River Road near Church Road.

In the 1840s, Rev. Henry Powers conducted occasional church services on the island and performed baptisms. Through the influence of Rev. Charles Fox, St. John's Episcopal Church was planned.

The Roman Catholic and Episcopal churches continue in their traditions of service to the community. Today they have been joined by Presbyterian, Christian Church, and Lutheran congregations who support the Interfaith Council in its ecumenical spirit of religious unity and cooperation.

Early school classes were taught by private tutors or clergymen and often conducted in residents' homes. Hunter School was a private school for boys started by the Reverend Moses Hunter in 1847. Grosse Ile students attended classes during the day while students from off-island boarded in the Hunter home, as many as nine at a time.

As school buildings were erected, more children were able to attend. The Grosse Ile School District of Monguagon Township purchased land on Church Road (then McCarty Road) near the Thoroughfare Canal to build a school, which opened around 1853. In the 1860s, compulsory attendance was mandated by the state and the legislature appropriated funding for schools. School attendance increased rapidly as the island became more populous and when teachers were hired by the school district. Some students continued to attend private schools on the island or boarding schools off-island.

Over the years, the Grosse Ile school system has promoted and maintained high academic standards with well over 90 percent of graduates attending college.

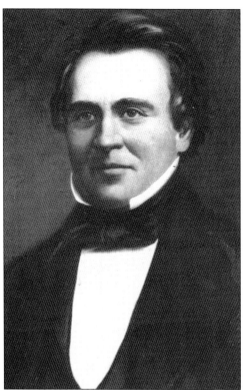

Charles Fox was born in 1815 in Westoe, England. Ordained in 1839, he was largely responsible for the establishment of St. John's Episcopal Church. In 1843, he purchased a farm on Grosse Ile. He married Maria Rucker, daughter of Sarah Macomb and John Anthony Rucker. After their farm home burned in 1854, the family moved to Hamtramck. Fox died during that summer of Asiatic cholera.

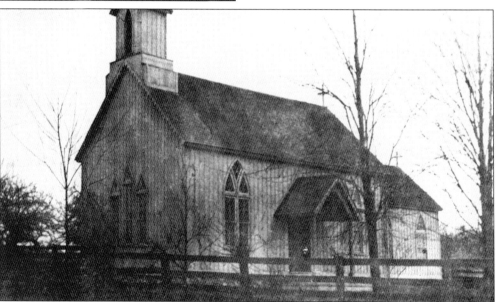

In April 1851, St. John's was organized with David Keith as warden. John Ballard, John Rucker Jr., Edward Keith, and Thomas Lewis were vestrymen who participated in its organization. St. John's parish included all the land northwest of the Thoroughfare Canal. In 1859, Bishop Samuel McCoskry appointed the Reverend Milton Ward as missionary clergyman to serve the parish. In addition to the families mentioned above, the parish register included the Stanton, Whitall, Groh, Johnson, and Reynolds families.

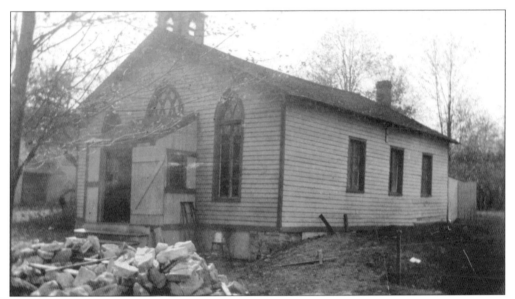

In 1869, the small Catholic community on Grosse Ile bought a one-room abandoned schoolhouse to use as a church. It was a modest enough beginning, but the people were proud of their first church and invited the bishop of Detroit Rev. Caspar Borgess to dedicate it. On March 21, 1871, the church was dedicated to God under the title of St. Anne, the patron saint of French sailors.

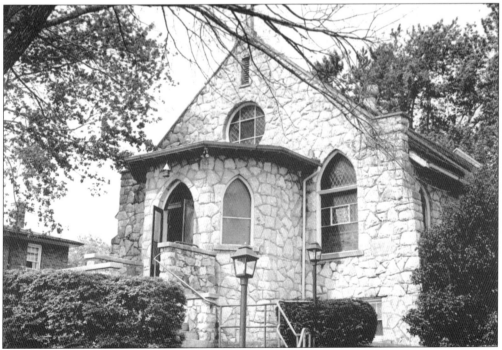

During 1914 and 1915, parishioners hauled stones from Stony Island or from the riverbank to a site next to their existing wooden church on East River Road. The cornerstone for the present Gothic-style church was laid in 1915. Under the direction of Michael Bourdineau, a stonemason from Amherstburg, Ontario, the stones were mortared in place. Completed in 1916, it was named Sacred Heart Church and was served by priests from surrounding parishes.

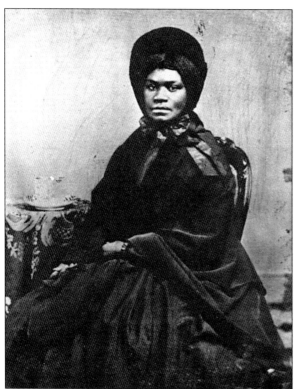

Elizabeth (Lisette) Denison (about 1793–1866) was born in Michigan. A slave, she gained her freedom by establishing residency in Canada. Returning to Michigan, she married Scipio Forth in 1827. It is believed that he died shortly thereafter. In 1831, she was employed by the Biddle family and resided with them for three decades. Her will entrusted William Biddle with $1,500 to establish a "proper Protestant Episcopal Church." (Courtesy St. James Episcopal Church.)

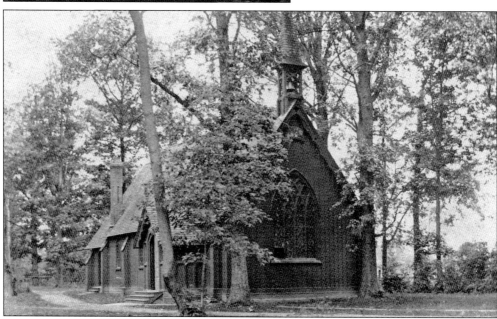

James Biddle provided land for the church just north of his home, and both Biddle brothers supplemented Lisette's bequest with additional funds. Designed by Detroit architect Gordon Lloyd, St. James Episcopal Church was built, and the Reverend Moses Hunter conducted the first service there in the spring of 1868. Benefit socials provided funds for pews, a lectern, and other furnishings. The church, now St. James Chapel, is on the National Register of Historic Places.

The Biddle memorial window by Tiffany Glass and Decorating Company of New York was unveiled July 13, 1898. At 11 feet high and five and a half feet wide, the *Angel of Praise* window cost $1,000. It was a gift to St. James from Col. John Biddle in memory of his mother, Susan Dayton (Ogden) Biddle (wife of William Biddle), who was organist and choir director at the church from 1868 until her death.

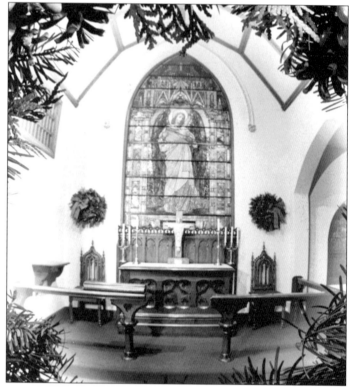

Prior to 1840, education took place in the home and was primarily the responsibility of mothers or tutors employed by one or more families. Public schools before 1866 were decentralized with one-room schoolhouses at various locations around the island allowing all children of school age the opportunity to attend. One of these, the "Notorious School House" is believed to have been located on Horsemill Road.

After several years of wrangling between residents on the east and west sides, those in favor of a single school for all island students prevailed, and in 1877, a three-room school was built on east side property now the site of the Grosse Ile Middle School. However, students on the southwest side of the island continued to attend the Sunnyside School, built in 1871. Pictured here are the students and teachers at East River School in 1898.

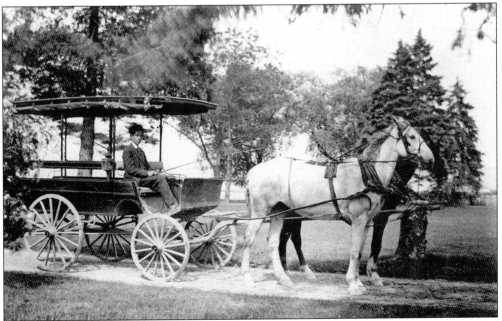

In the late 1800s, a horse-drawn bus brought students to school. Children were transported by bobsled in the winter. When the snow was deep, residents were isolated and school attendance dropped off until the arrival of better weather. By 1917, an automobile bus carried Grosse Ile students to their respective schools.

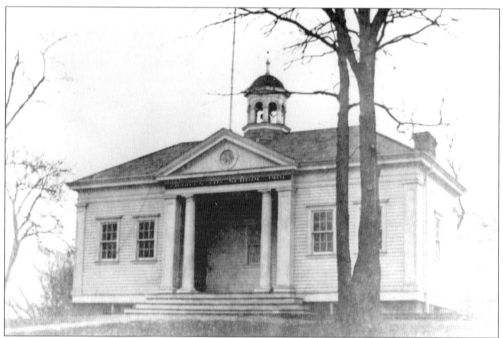

West side residents apparently remained unhappy with the accessibility of a school for their children, and the Fox School was built in 1901 on property purchased from the Rucker family. It replaced an earlier one-room log structure where the Reverend Charles Fox had held church services and which, at times, doubled as a school.

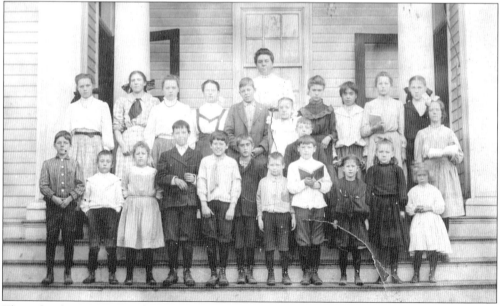

This school picture was taken in 1920 in front of the Fox School. There were typically 25 to 30 pupils attending the first through eighth grades housed in this building. All island students commuted to the mainland to continue their education. The building, now a private residence, has been enlarged, but the appearance of the front is the same, even the cupola that housed the school bell.

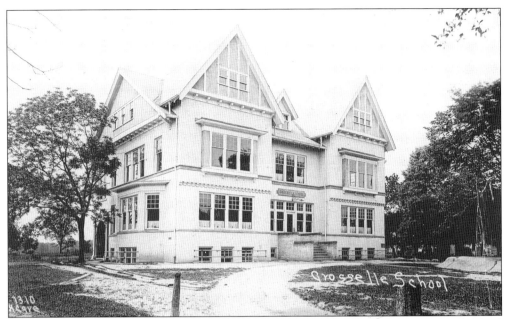

The 1911 School replaced the East River School and was the first graded, consolidated school on Grosse Ile, replacing all other schools on the island. High school classes were instituted, and the first class was graduated in 1916. In 1922, a combination auditorium and gymnasium was added onto the school.

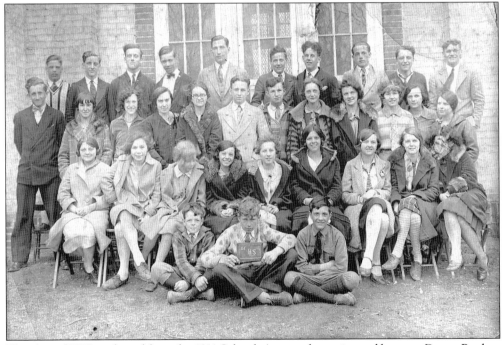

The class of 1927 graduated from the 1911 School. Among those pictured here are Deane Rucker, Robert Lake, Leonard Johnson, Ellen Hughes, Grace Goniea, Katherine Rucker, Charlotte Hughes, Elsie Warrow, Mary Grace Linley, Vivian Bremer, Marjorie Alexander, Arthur Kinsman, and Richard Lake.

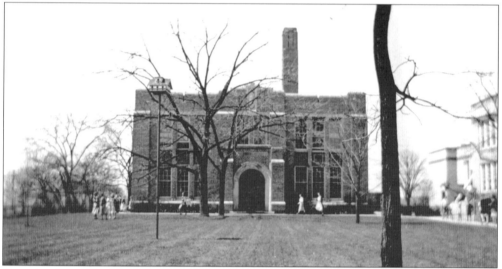

Completed in 1929 at the cost of approximately $125,000, a new high school was built next to the 1911 building. Grades 7 through 12 moved into this building. Addition of a gymnasium and cafeteria and other classrooms was completed in 1952. In 1956, a library and 11 classrooms were added along with a faculty area and a remodeled office area. The school was replaced by a new high school built on Gray's Drive in 1964.

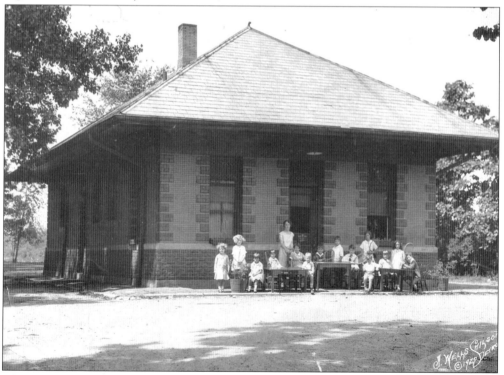

The Island Day School started in 1925. Nan Cole was owner and teacher of this private school housed in the train depot that is now the Grosse Ile Historical Museum. Cole rented the building for $200 annually from Ida Webb, who had leased the land from the Michigan Central Railroad. Nan Cole left Grosse Ile in 1929 to teach at the Liggett School in Detroit.

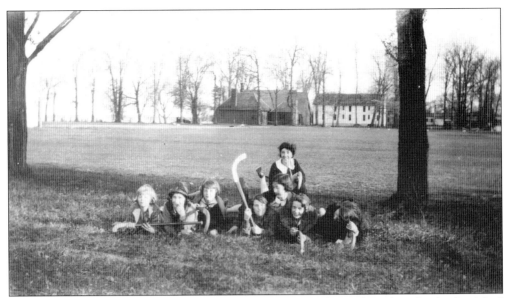

Students at Nan Cole's school pose with their hockey sticks. Before the island school had organized sports, boys and girls came from the public school to assemble teams for field hockey games. In the background are the St. James Episcopal Church (left) and the Island House Hotel. The vacant area between was the site of the former country club and casino.

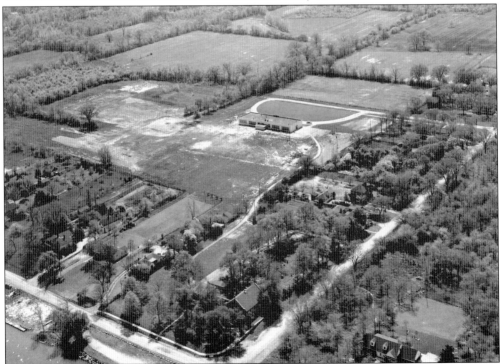

In 1947, Sacred Heart School (center) opened with only three of the eight classrooms occupied by 102 pupils in grades 1 through 6. As enrollment increased, four classrooms and a combination gymnasium-cafeteria were added. In the center foreground is the present St. Anne's Chapel on East River Road at the corner of Church Road.

Eight

U.S. NAVAL AIR STATION GROSSE ILE

Aviation came to Grosse Ile in the early 1920s when a pioneer air club, headed by Carl B. Fritsche, purchased property on the southern end of the island. Fritsche teamed up with balloonist and designer Ralph Upson to organize the Aircraft Development Corporation (ADC) with the intent of building the first all-metal dirigible. The company built a huge hangar in which to construct the metal airship and cleared a 3,000-foot-diameter circle as a landing field. In the fall of 1928, Wings, Inc., erected a hangar to provide flight instruction and to sell and service aircraft. The facilities were sold to the Curtiss-Wright Aeronautical Corporation, which opened a ground school.

Naval aviation arrived on the scene in 1928 when a little tin hangar, loaded on a barge, arrived at the ADC site. By July 1929, the base was ready for operations as a reserve aviation base. During World War II, the base developed into an important center for military flight training and was expanded to accommodate large numbers of American and British fliers. By the end of 1942, Grosse Ile was leading all naval reserve bases in the United States in primary training. In recognition of this, the U.S. Navy changed its official designation to U.S. Naval Air Station, Grosse Ile, Michigan.

In 1946, Grosse Ile became one of 21 stations across the country to become part of the new Naval Air Reserve program. By 1949, there were 17 squadrons, each with its own training schedule. The program attracted weekend reservists from Michigan and northern Ohio. Grosse Ile units were called to duty in the Berlin Airlift, Korea, and the American-British build-up in the Middle East, as well as to respond to the threat of the Berlin Wall.

In 1964, the Department of Defense ordered the closing of 22 military installations. U.S. Naval Air Station Grosse Ile was one of them. The final move was made to Selfridge Air Force Base in 1969. A small contingent of fire and maintenance personnel remained at the Grosse Ile base until 1970 when the Township of Grosse Ile took possession and designated the site as the General Aviation Airport and Industrial Park.

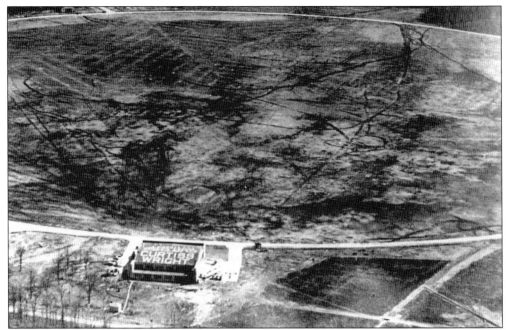

Around 1930, the Curtiss-Wright Aeronautical Corporation undertook a major expansion program, opening a ground school and adding glider training. The airport was the site of a national model airplane contest as well as the departure point for the first Intercollegiate Air Tour. In the summer of 1931, Amelia Earhart trained here before entering a women's speed-flying contest. The metal airship named the ZMC-2 was built in the hangar at upper right.

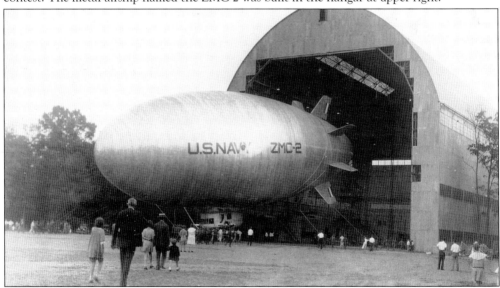

The ZMC-2 (Zeppelin Metal Clad 200,000-cubic-foot capacity) was the only successful metal-kinned airship ever built. Nicknamed the *Tin Bubble*, it was successfully launched in 1929 and delivered to Lakehurst, New Jersey. The onset of the Depression foiled any plans for building additional metal-clads, and subsequent blimp crashes and the Hindenburg disaster ended the era of dirigibles. The ZMC-2 continued flying for the U.S. Navy on patrols and maneuvers until 1941.

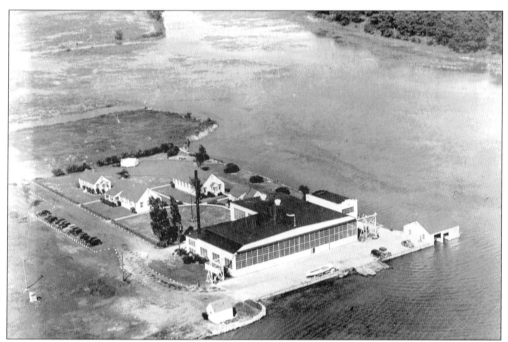

Funds were obtained in 1927 from the State of Michigan to lease Grosse Ile property for a new seaplane base. Work was begun; dredging, driving pilings, erecting hangars, and a repair shop, living quarters, and other buildings were constructed on the piles. By July 1929, the base was ready for operations and eight officers and 30-plus enlisted men moved to the U.S. Reserve Aviation Base, Grosse Ile, Michigan.

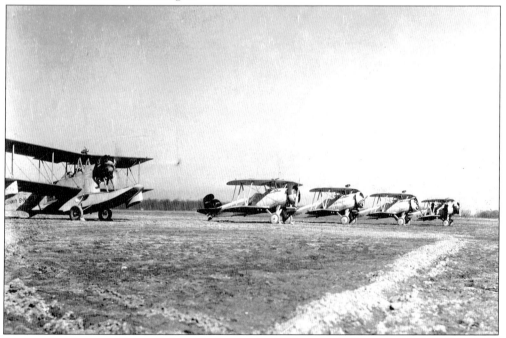

Among the planes in Grosse Ile's stable during the 1930s were the Loening OL-9 (left) and the Curtiss O2C-1 Helldiver (right group), shown here.

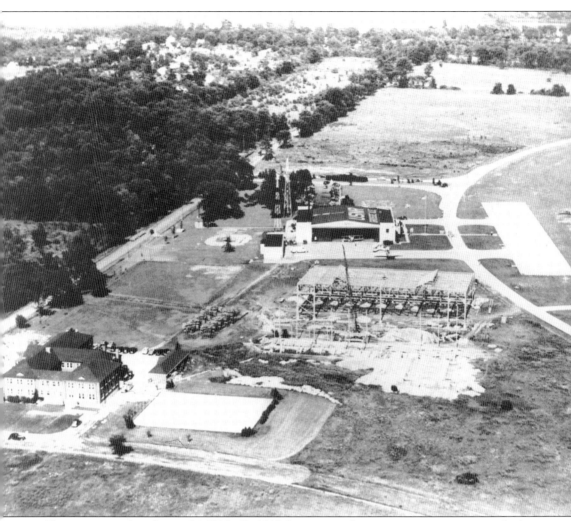

Expansion was slow during the 1930s. By 1940, however, with war imminent, activity on the base increased at an amazing tempo. This aerial view shows the expansion of the old Curtiss-Wright barracks (left), the Curtiss-Wright hangar (center), and the construction of a new hangar (between the barracks and the old hangar). The Aircraft Development Corporation offered the sale of its property to the federal government for $600,000. In 1942, a $5 million construction program almost doubled the size of the base, expanding it to 604 acres and extending it north of Groh Road. New buildings included classrooms, living quarters, a recreation hall, an Olympic-size indoor swimming pool, and a medical dispensary. A large round pad of concrete was laid in the airfield, and three runways were laid around it in a triangular pattern.

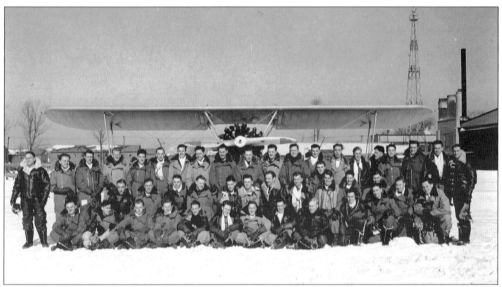

The first British young men arrived in 1941. One hundred young cadets came to Grosse Ile to receive their primary flight training. Soon there would be more than 500 on the base. After a one-month stay, those who did not wash out would go on to Pensacola, Florida, to complete their flight training. Since this was the phase where most cadets washed out, Grosse Ile was known as one of the Elimination bases, or E-bases. In April 1944, as the war in Europe was ending, Great Britain reduced the number of cadets at American bases. The last 400 cadets at Grosse Ile were transferred to the U.S. Naval Air Station at Lambert Field in St. Louis. They were the last of 1,800 Royal Air Force Fleet Air Arm trainees at Grosse Ile. Pictured here in 1942 are the 40th Pilots Course, Course 22 in November 1942 (above) and a group shipping out for sea duty.

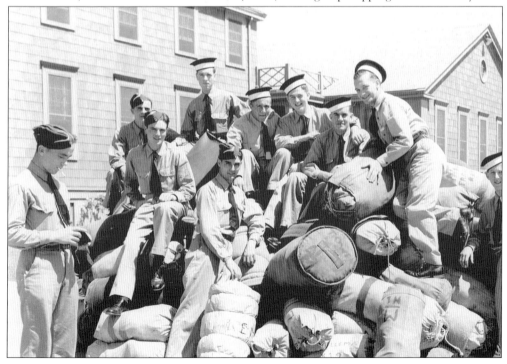

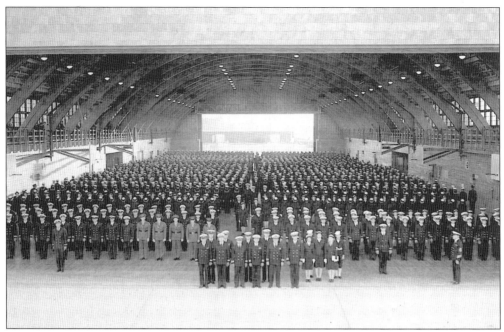

In 1942, a huge indoor drill hall, with a high arched roof, was erected on Groh Road, just east of the old Curtiss-Wright Hangar. It was used for inspections and physical training, including basketball and boxing, as well as for dances sponsored by the Grosse Ile USO. In later years, the building was used to store and maintain aircraft and is now an indoor tennis facility.

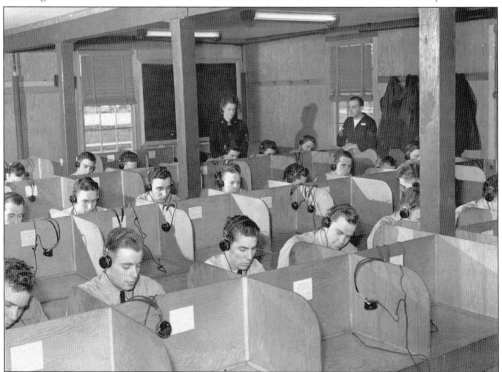

Cadets are being instructed in Radio Ground School.

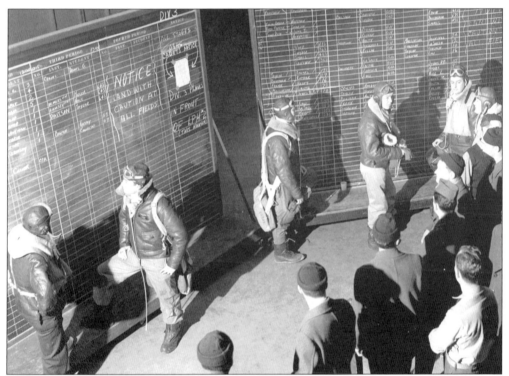

Flight assignments were a part of each day's training. Cadets here are checking the status board for their daily assignments.

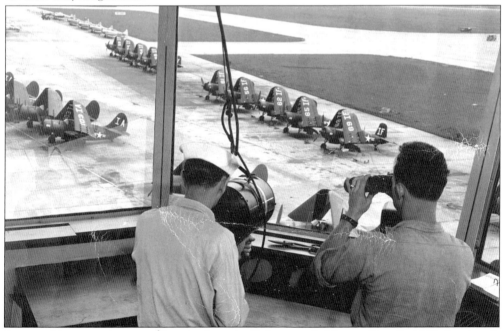

Personnel here are observing Corsairs from the flight tower in Hangar One. By 1943, the aircraft assignment was the largest collection of aircraft ever assigned to U.S. Naval Air Station Grosse Ile with a total of 211 aircraft of various models.

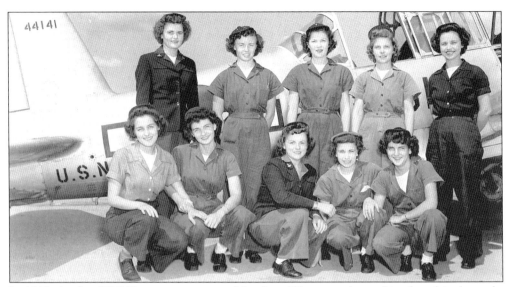

In 1943, the first WAVE contingent arrived for duty. They were housed in the white barracks facing Groh Road and west of the bachelor officers' quarters. WAVES worked alongside the sailors in almost every capacity and operation on the base—administrative, dispensary, control tower, weather, supply department, and others.

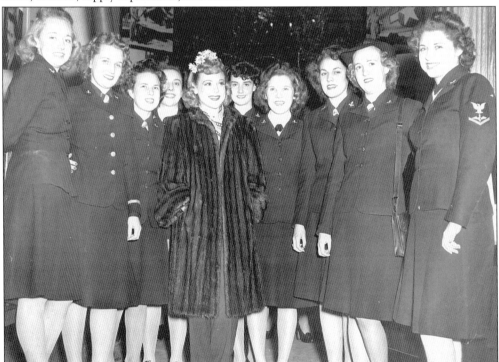

Many celebrities visited the base for the entertainment of the troops. Pictured here with the WAVES in 1943 is skating superstar Sonja Henie. Also that year, the Coca-Cola *Parade of Spotlight Bands* broadcast from the base. Other performers included Tony Pastor, Vaughan Monroe, Tommy Dorsey, and Ed Sullivan. From the world of sports the Detroit Lions played a practice game on the base and Detroit Tigers Cy Perkins and Mickey Cochrane also played here.

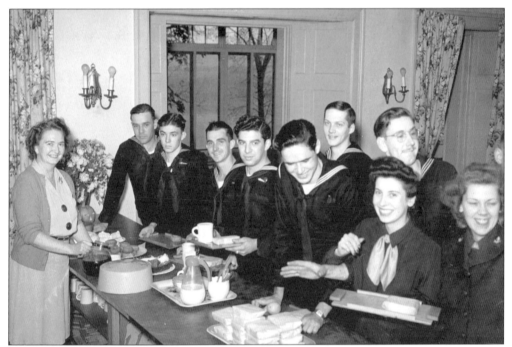

The Olds mansion (formerly used by Carl Fritsche's air club) became the site of the USO. Personnel from the base could relax from their work and training while meeting young ladies from Grosse Ile and neighboring communities. USO dances were held in the mansion's ballroom and also at the drill hall on the base.

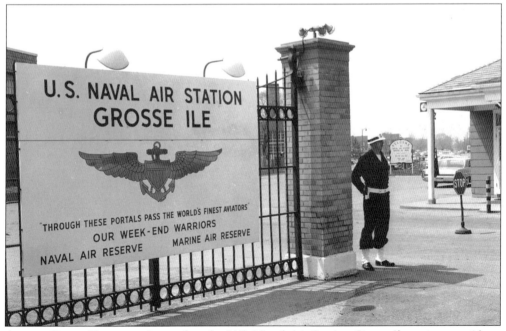

Airman Dewey Kintz stands guard at the U.S. Naval Air Station Grosse Ile main gate. Along with the reserve squadrons the base included continuous active-duty personnel. Both navy and marine reserves, along with their training, answered distress calls and performed rescues.

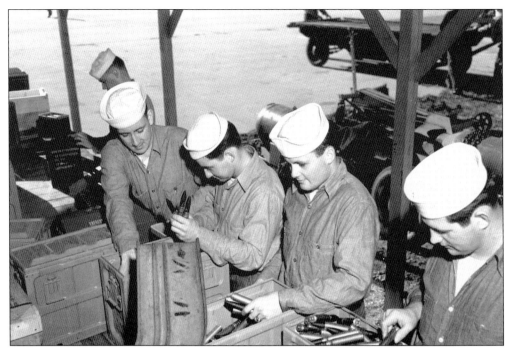

Squadron personnel undertook all tasks pertaining to ordnance equipment. Shown here are ordnance men from VA735 preparing 20-millimeter shells for loading in wing guns on Martin Marauder attack planes in the early 1950s.

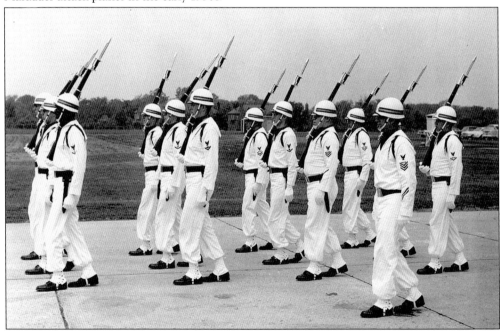

The Tars and Rifles Drill Team was organized in 1958 and staffed by volunteer active-duty enlisted personnel. Many station keepers proudly served with this unit. The team performed at many military, civic, school, and sports events and competitions and received numerous awards. As a result, navy recruiting was significantly enhanced.

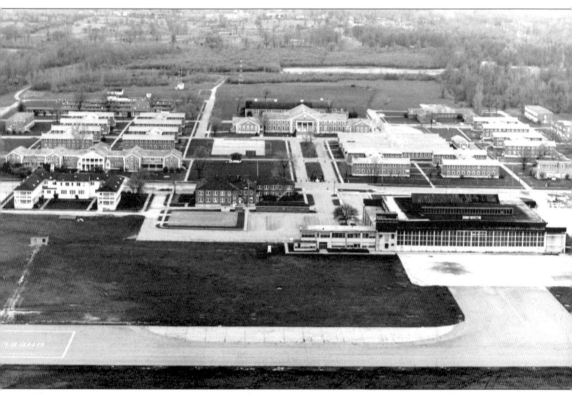

The reasons given for closing U.S. Naval Air Station Grosse Ile were three-fold: the runways could not be extended for jet operation, Selfridge was readily available, and the buildings would require expensive upkeep. This aerial view shows the base as the navy departed in 1969. In the foreground, from left to right, are the white barracks and mess hall (WAVES), the officers' club and bachelor officers' quarters, and Hangar One. In the mid-section between the foreground and background from the left are the captain's quarters and bachelor officers' quarters annex in front of the enlisted men's barracks, the administration and instruction buildings in front of the mess hall and hobby shop, the link trainer building in front of the brig, and rental housing for navy families. In the background on the left are sickbay, bachelor officers' quarters, chapel, and enlisted men's barracks, the recreation hall in front of the swimming pool, and the gas station.

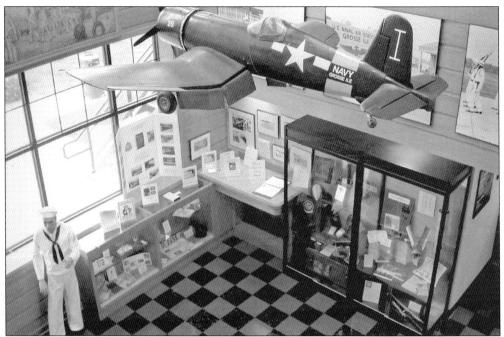

In 2001, the township supervisor invited the Grosse Ile Historical Society to establish a museum and photograph gallery in the lobby and halls of the recently renovated Hangar One that now serves as township offices. Accepting eagerly, the society began gathering artifacts and photographs from its own collection as well as from veterans around the world. The result is a lobby museum with several hundred artifacts and a photograph gallery throughout the halls of the entire building. In addition, a memorial garden immediately to the south of the hangar was established as a living memorial to the men and women who served at this "unsinkable aircraft carrier," U.S. Naval Air Station Grosse Ile.

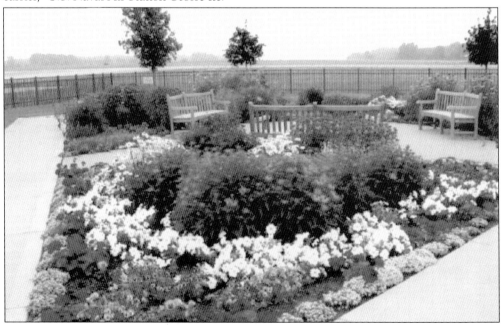

Nine

A Boy's View of the Island

This selection of views from a recently acquired collection of 270 glass plate negatives is being published here for the first time. From a tag on the wooden box in which the negatives were housed it is known that the pictures were taken about 1903 and the photographer was P. S. Gage. Each paper negative envelope was marked with the subject and date of that particular image.

A check of the 1900 U.S. census for Grosse Ile revealed that Philip S. Gage was the son of William T. and Elizabeth Gage and had been born in Michigan in 1885. The dates on the envelopes ranged from 1898 to 1902, so Philip took the pictures between the ages of 13 and 17. Philip had two brothers, William, born in 1872, and Alexander, born in 1874. From other sources it was learned that his father, William T. Gage, was a veteran of the Civil War, a graduate of Dartmouth College, and former head of the Hartford Female Seminary in Hartford, Connecticut. In 1900, William T. had an insurance agency in Detroit and was active in the Detroit Post No. 384, GAR. After the death of Philip's mother in about 1904, William T. married Julia Bury, daughter of longtime neighbors William and Eliza Bury. During World War I, they moved into the "cottage" just north of their house, which apparently was built some time after these pictures were taken. William T. died in 1935, but Julia continued to live in their house well into the 1950s.

Philip left Grosse Ile to attend West Point and never returned to live on the island. He married Irene Toll of Detroit, and they had two children, Philip S. Jr. and Betty. He spent his entire career in the U.S. Army, rising eventually to the rank of brigadier general. He died in Atlanta, Georgia, in 1982 at age 96.

The majority of the pictures in this collection focus on Grosse Ile and particularly on the area around the Gage home on East River Road, not far north of Ferry Road. Although some of the negatives suffer exposure problems or sun glare, the images are worthy of publication because they show scenes of Grosse Ile unavailable elsewhere.

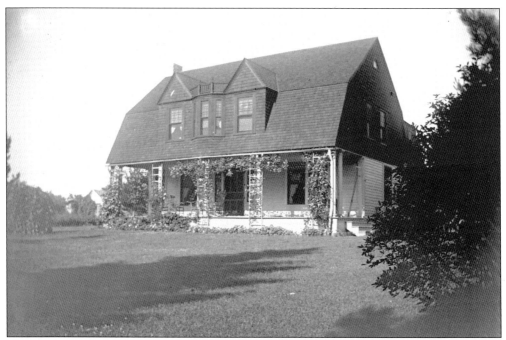

The gambrel-roofed house on East River Road, where Philip Gage lived with his family, is still recognizable even though it has undergone significant changes since this picture was taken in 1898. Also standing is the home next door, in which the elder Gages lived for many years.

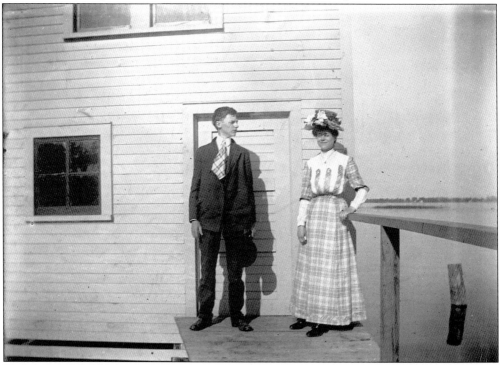

Philip's friend Ralf Emerson took this picture of him with Gretchen Goebel on the walk in front of the family's boathouse. The picture is dated 1900 so Gage would have been 15 years old.

The Gage family poses for a picture on the lawn north of their home. William T. and Elizabeth Gage are seated on chairs with Philip on the lawn in front of them. The young man leaning over Mr. Gage's shoulder is William H. (Billie) Gage, Philip's older brother. The other young man is identified as Bill Jaquith.

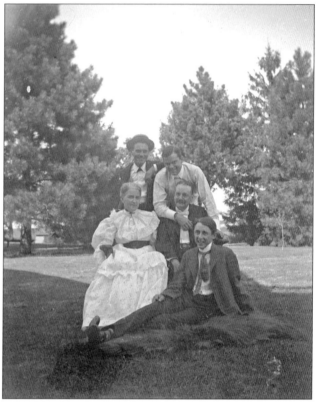

The house of Seth E. Smith, the Gages' neighbor immediately to the north, is shown as it looked in 1899. The house, which has undergone extensive remodeling, still stands. Smith was a lumber and coal dealer on the island and also served as a rural mail carrier.

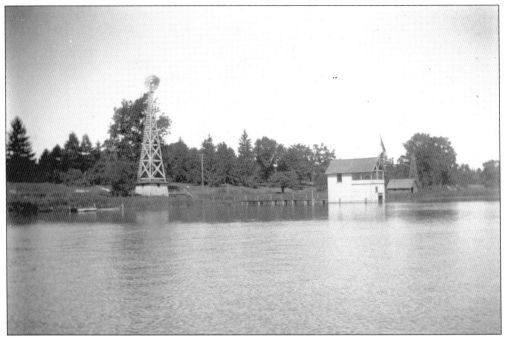

This view from the river shows the Gages' windmill and two-story boathouse with the Smith boathouse beyond. In those days, much of the shoreline between Ferry and Church Roads was covered with a cattail marsh. Long boardwalks provided access to the boathouses, built at the edge of the navigable water.

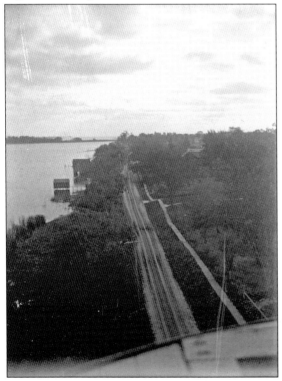

Philip Gage took this picture in 1898 looking south on East River Road from the top of their windmill. The cupola just visible in the distance marks the site of James I. David's home just south of Ferry Road. It is interesting to note that East River Road had wooden sidewalks in those days, saving pedestrians from having to walk in the dusty (or muddy) road.

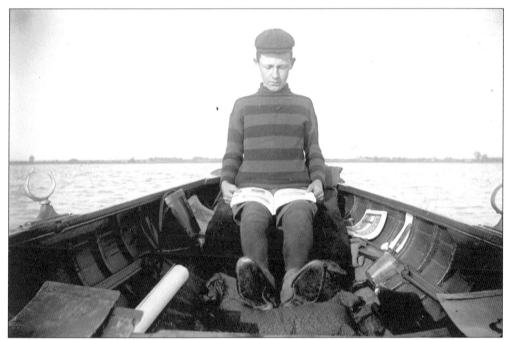

Albert Bury, who lived with his grandparents William and Eliza (Reaume) Bury in a house just south of the Gages, was Philip's age and a frequent companion. Here they are rowing to Fighting Island and had taken some "pillows, books and other luxuries" on the long trip for comfort and entertainment.

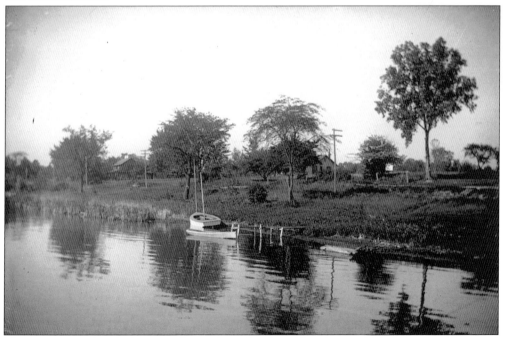

This view was taken looking southwest from the Gages' boathouse. Alfred Bury's rowboat and his sailboat, *Lottie*, are shown tied up at the Burys' dock. The cattail growth along the shore in this direction is much less than in the earlier view looking north.

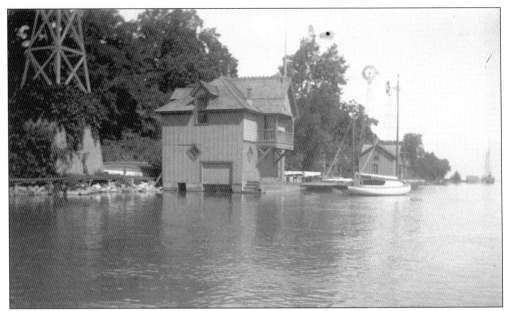

Boathouses, such as this one owned by the Copeland family, were a common sight along Grosse Ile's shoreline in 1902. The Copeland house stood on East River Road, the second lot south of Macomb Street. A similar boathouse seen in the distance belonged to the Allen families.

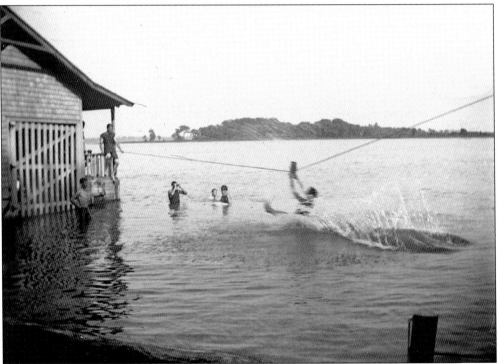

Philip Gage described this picture as "Wallace Osborn just hitting the water on a 'chute the chutes' us fellows had made out of a rope from the windmill boathouse down at the Anderson's." The Osborn and Anderson homes, both still standing, (see page 82) are south of Macomb Street in the East River Road Historic District.

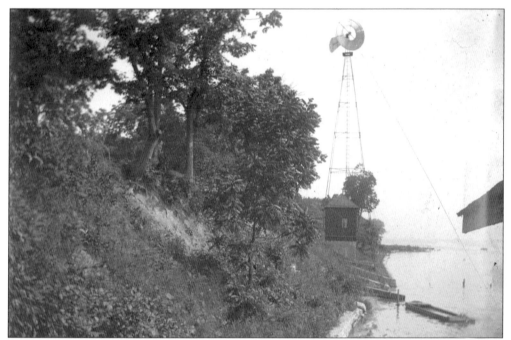

The William and Orville Allen families lived in a double house they had built in the 1880s on the southwest corner of East River Road and Macomb Street. The Allen children, some of whom appear in Gage's photographs, often entertained their friends in the family's two-story boathouse. This view was taken looking north from the boathouse along the steep riverbank.

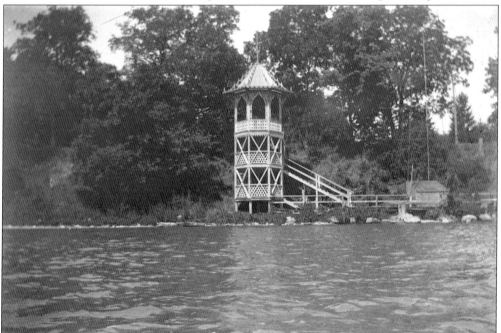

The Edward Lyon home, long ago demolished, stood on the hill just north of the present Gray's Drive. It had an elaborate three-story "summer house" down by the river. An old picture of the Lyon home shows it had a tower, which was apparently used as the design for the summer house.

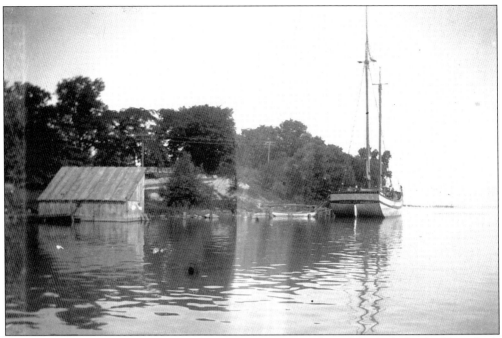

Shortly after Horace Gray moved to Grosse Ile in 1846, he enlarged the dock that had been built some years earlier in what became known as Gray's Hollow or Gray's Landing. This dock was one of two principal docks for passengers and goods arriving on the east side of Grosse Ile; the other was Ives Dock, north of Horsemill Road. Philip Gage photographed the schooner *Isabella* tied up at Gray's dock in the fall of 1901.

William T. Gage's farm of approximately 30 acres stretched west from the Detroit River to the Thoroughfare Canal. As was typical on Grosse Ile in those days, he worked in the city and hired others to do the farm work. Here "our man" Hugh Phillips is shown bringing in the morning's milk. The barn is in the background.

In 1898, Philip Gage took this picture of the cows Christabelle and Genevieve standing in the barnyard. The Gages also raised pigs and chickens and kept a team of horses to pull their carriage. Several of the farm buildings are seen at the left with the windmill beyond. Nearly every home in those days had a windmill to pump river water for farm and household use.

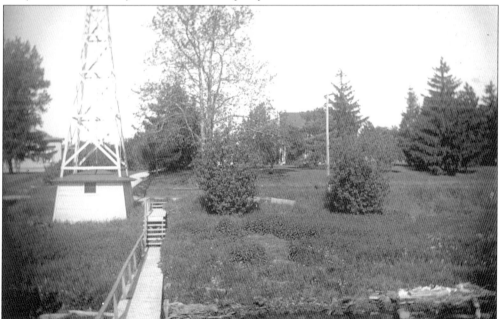

This view, looking directly west from the second story of the Gages' boathouse, shows the boardwalk and steps leading up to the house, partially shrouded by trees on the bank beyond. The house to the left of the windmill is the home of William and Eliza Bury and of Philip's friend Albert.

Taken at a time when most photography depended on available light, Philip Gage wisely left the front door open so he could capture this interior view of the sitting room. Bouquets of home-grown flowers complement the simple, but comfortable, furnishings of the room.

In addition to growing corn, potatoes, and other vegetables, the Gages had an orchard with pear and apple trees and many flower beds. This view was taken in the orchard and shows a "fleur de lis" bed with the icehouse and water tank behind. Although the Gage home is described as having a "bathroom," the small building just right of the icehouse may be an outhouse.

Philip took this picture from the Gages' backyard looking south across the fields toward Ferry Road. The Gages' driveway and peony bed are in the foreground; beyond are some outbuildings behind the Bury home. The house in the distance fronts on Ferry Road and may be a house that still stands on the north side of Ferry, not far from East River Road.

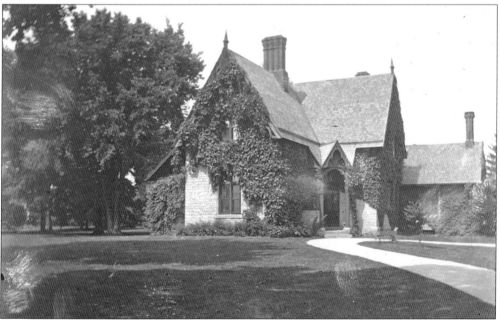

As has been seen, sometimes Philip would take his camera out in a boat or to other locations on the island he considered interesting. In 1898, he photographed the home of Judge Samuel T. Douglass. A Gothic cottage built in 1860 of local limestone, it was designed by Detroit architect Gordon Lloyd and stands in the East River Road Historic District.

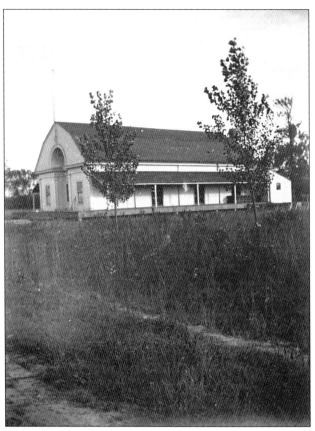

Around 1890, a small group of island residents formed the Willow Bank Dancing Club and in 1893, as their social activities increased, built this clubhouse on Casino Road (now Island Boulevard) about one-half mile west of East River Road. Philip Gage took a picture of the building's interior in 1898 "when the Naval Reserves came home from the Spanish American War. This was the greatest dance the casino had ever seen, and probably ever will see." About 1908, the casino was moved to a location on East River Road just north of St. James Church where it was used as a clubhouse for the newly formed Grosse Ile Country Club. The schools also used the building for gym classes and school assemblies. After the Grosse Ile Golf and County Club was formed in 1919, the casino was moved again and continued to be used as a clubhouse until it burned in 1947.

BIBLIOGRAPHY

Burton, Clarence. *The City of Detroit, 1701–1922.* Vol. 6. Detroit: S. J. Clark Publishing Company, 1922.

Burton, Clarence M., and M. Agnes Burton. *History of Wayne County and the City of Detroit, Michigan.* Vol. 3. Detroit: S. J. Clarke Publishing Company, 1930.

Catlin, George B. ed. *Historic Michigan, Land of the Great Lakes.* Vol. 3. Dayton, OH: National Historical Association, 1924.

Devendorf, John F. *Great Lakes Bulk Carriers 1869–1985.* South Bend, IN: Apollo Printing and Graphics Center, 1995.

DeWindt, Edwina, and Joseph C. DeWindt. *Our Fame and Fortune in Wyandotte.* Wyandotte, MI: Rotary Club of Wyandotte, 1985.

Dixon, Michael M. *When Detroit Rode the Waves.* Detroit: Mervue Publications, 2001.

George, Henry. *Hickory Island and Hickory Island Company.* Self-published, 1964.

Hartig, John H. ed. *Honoring Our Detroit River.* Bloomfield Hills, MI: Cranbrook, 2003.

Jewett, Robert Lee. "The Tin Bubble." *Air Power Magazine,* Vol. 4, No. 8. September 1974. pp. 44–51.

Keith, Julia J. *Our Little Island Grosse Ile.* Self-published, 1931.

Lake Carriers Association. "Annual Report 1906." 1906.

Leake, Paul. *History of Detroit.* Vol. 1. Detroit: Lewis Publishing Company, 1912.

May, George S. *Pictorial History of Michigan: The Early Years.* Grand Rapids, MI: Erdmans, 1967.

Melton, Lt. Comdr. Dick, USNR. *The Forty Year Hitch.* Publisher's Consulting Service, Inc., 1970.

Morrow, Walker C. *The Metalclad Airship ZMC-2.* Privately printed, 1987.

Poremba, David Lee. *Detroit: A Motor City History.* Charleston, SC: Arcadia Publishing, 2001.

Neubauer, Hal, and Stanley Outlaw. *A Pictorial History of the U.S. Naval Air Station Grosse Ile, Michigan.* Privately printed, 2004.

Schoolcraft, Henry R. *History of the Indian Tribes of North America.* Philadelphia: Lippincott, 1857.

Smith, Rockne. *Our "Downriver" River: Nautical History and Tales of the Lower Detroit River.* Self-published, 1997.

Swan, Isabella. *The Deep Roots.* Grosse Ile, MI: Self-published, 1977.

Tennant, Robert D. Jr. *Canada Southern Country.* Erin, Ontario: Boston Mills Press, 1991.

Women's Improvement Association. *The Treaty Tree and Memorial Tablet.* Lansing, MI: Crawford, 1907.

Woodford, Arthur M. *This is Detroit 1701–2001.* Detroit: Wayne State University Press, 2001.

www.civilization.ca

www.grosseilebridge.com

www.loc.gov

www.lre.usace.army.mil

www.museedelaguerre.ca

ACROSS AMERICA, PEOPLE ARE DISCOVERING SOMETHING WONDERFUL. *THEIR HERITAGE.*

Arcadia Publishing is the leading local history publisher in the United States. With more than 3,000 titles in print and hundreds of new titles released every year, Arcadia has extensive specialized experience chronicling the history of communities and celebrating America's hidden stories, bringing to life the people, places, and events from the past. To discover the history of other communities across the nation, please visit:

www.arcadiapublishing.com

Customized search tools allow you to find regional history books about the town where you grew up, the cities where your friends and family live, the town where your parents met, or even that retirement spot you've been dreaming about.